TAKING BETTER
TRAVEL PHOTOS

TAKING BETTER
TRAVEL PHOTOS

Published by Time-Life Books in association with Kodak

TAKING BETTER TRAVEL PHOTOS

Created and designed by Mitchell Beazley International
in association with Kodak and TIME-LIFE BOOKS

Editor-in-Chief
Jack Tresidder

Series Editor
John Roberts

Art Editor
Mel Petersen

Editors
Louise Earwaker
Richard Platt
Carolyn Ryden

Designers
Marnie Searchwell
Lisa Tai

Assistant Designer
Stewart Moore

Picture Researchers
Brigitte Arora
Nicky Hughes
Beverly Tunbridge

Editorial Assistant
Margaret Little

Production
Peter Phillips
Jean Rigby

Consulting Photographer
Michael Freeman

Coordinating Editors for Kodak
John Fish
Kenneth Oberg
Jacalyn Salitan

Consulting Editor for Time-Life Books
Thomas Dickey

Published in the United States
and Canada by TIME-LIFE BOOKS

President
Reginald K. Brack Jr.

Editor
George Constable

The KODAK Library of Creative Photography
© Kodak Limited. All rights reserved

Taking Better Travel Photos
© Kodak Limited, Mitchell Beazley Publishers,
Salvat Editores, S.A., 1983

Library of Congress catalog card number 82-629-79
ISBN 0-86706-218-5
LSB 73 20L 07
ISBN 0-86706-220-7 (retail)

Contents

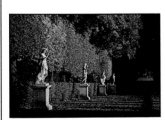

THE TRAVELING CAMERA

Travel photography is a creative adventure. Away from home, you have the opportunity to record the unfamiliar with a fresh eye. This can be as true of a regular family vacation as of rare and special trips to exotic places such as those pictured on the following nine pages.

Purely as records of experience, travel photos are often irreplaceable – you cannot go back. This means that to find, take and bring home an accurate record you need to be well prepared. An important part of this book covers such essentially practical matters as what equipment to carry and how to look after it. There are also general tips on travel formalities and on the challenges of varying locations. And a final section shows how to put it all together in a slide show or trip album.

But travel photos can be more than by-products of a trip. Vacations and journeys give you the luxury of time – time to observe the beauties or oddities of the world and to compose images that capture the atmosphere and spirit of people and places. By traveling as a photographer and with a photographer's selective eye, you can come home with a collection of images as evocative as the ones in this portfolio.

The Taj Mahal, framed in a view from the Agra fort, appears as a hazy outline against the setting sun. The pair of monkeys playing on the parapet adds lively foreground interest to this unusual view of a much-photographed landmark. By just masking the sun with the top of the alcove frame, the photographer was able to follow the ordinary exposure reading.

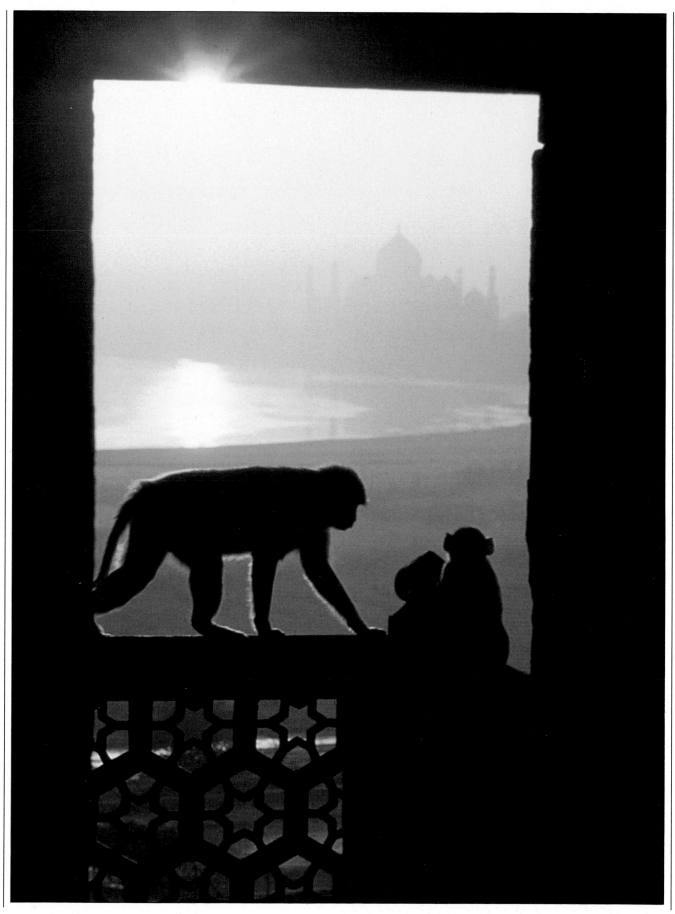

A yacht lies moored on a tranquil sea at Antigua. The photographer chose his viewpoint carefully, off-centering the main subject and including the small island and the low-lying clouds to break up the smooth expanse of water and sky. A polarizing filter helped to deepen the brilliant blues.

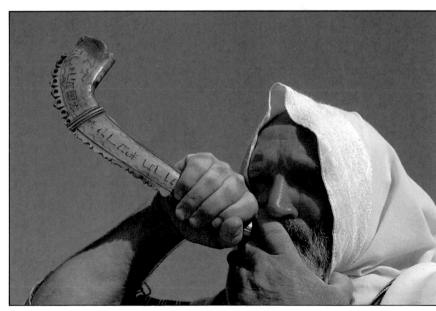

An Israeli elder blows the shofar – a ram's-horn trumpet – to herald the beginning of the Jewish New Year. The photographer closed in with a telephoto lens to fill the frame with selected details of the subject: the hands holding the ornate horn inscribed with Hebrew characters, the bearded face and ceremonial headdress.

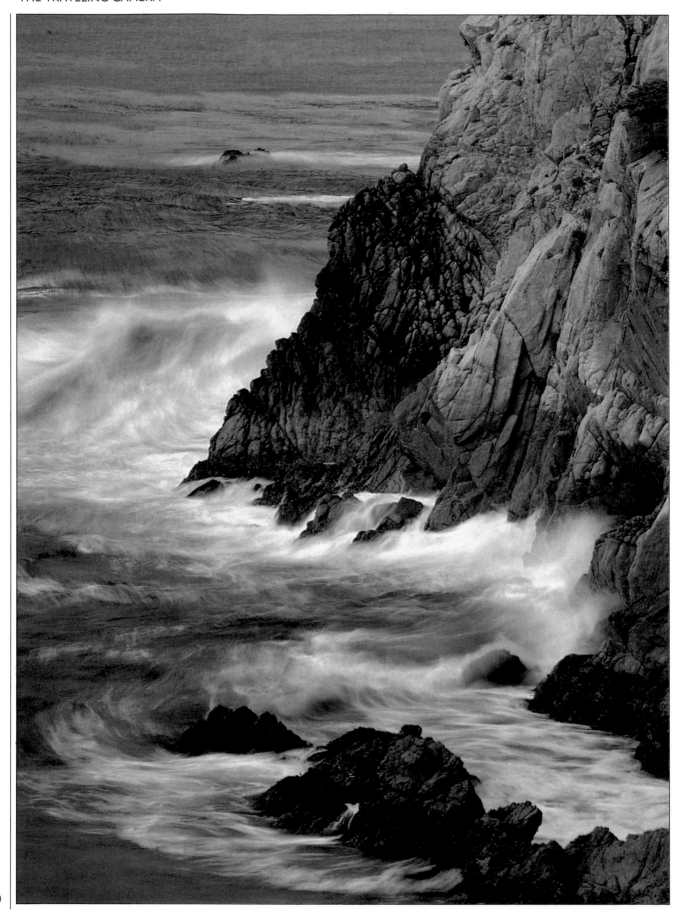

Waves pound the rocky promontory of Point Lobos, California – one of the most photographed of America's scenic coasts. To emphasize the inexorable force of the sea in its timeless assault on the land, the photographer used a 200mm telephoto lens to close in on the breakers and blurred their motion with a slow shutter speed of 1/8.

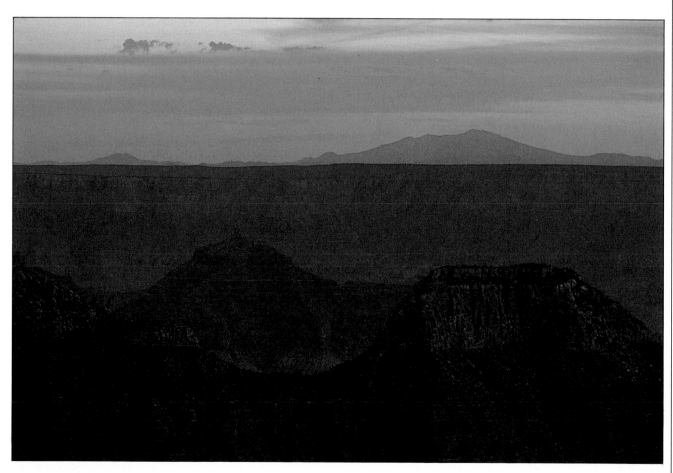

The calm of evening descends on the Grand Canyon, bathed in the soft and warm light of the setting sun. Careful choice of this as the best time of day to express the character of the famous landscape gave the picture its mood and its originality. A half-stop less exposure than indicated by the camera's meter brought out the subtle colors of stone and sky (ISO 64 film: 1/60 at f/4).

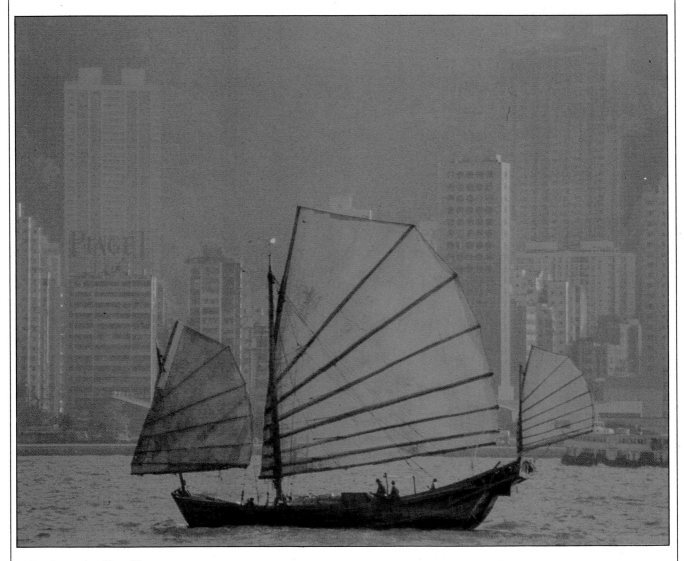

A junk crossing Hong Kong
harbor picks up the soft
light of dawn on its fan-
shaped sails. Against the
background of the modern
city, the traditional craft
provides a contrast between
old and new, and at once
identifies the scene.

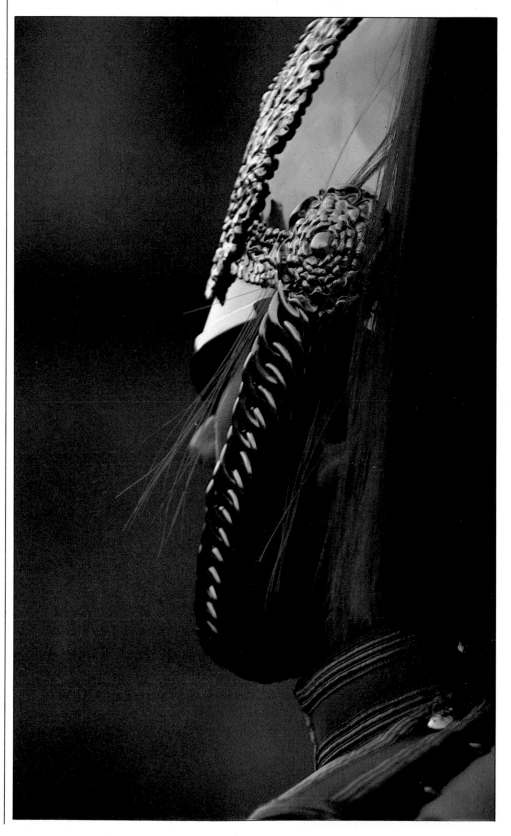

A Household Cavalryman stands motionless on parade in Whitehall, London. The unusual viewpoint and the imaginative cropping of the image focuses attention on the ornate burnished helmet and braided collar – details that convey a ritual splendor.

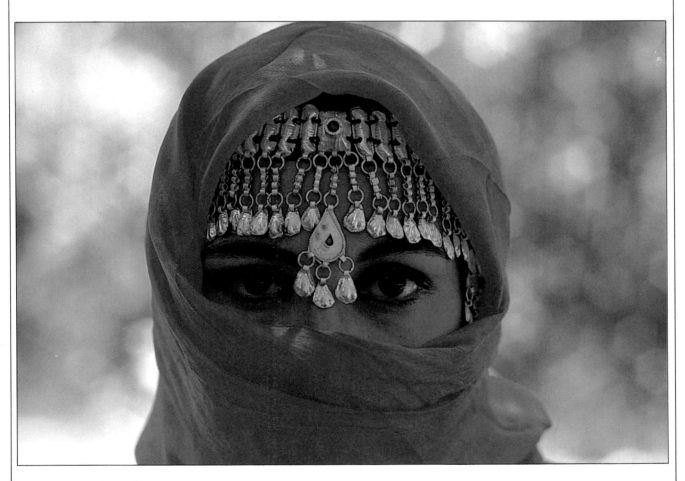

A Bedouin confronts the camera with eloquent dark eyes. The beautiful silver jewelry, the colorful veil and the mingled candor and mystery in the woman's gaze give this portrait magnetic charm. A wide aperture threw the background out of focus to make a soft-hued setting.

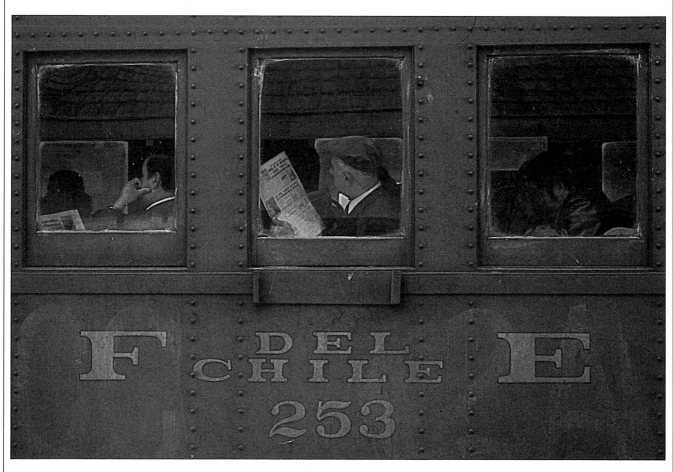

Passengers on a Chilean train read their newspapers to while away the journey. Observing the crowded train draw into the station, the photographer tightly framed one car so as to include the identifying lettering. The result was this fascinating vignette of everyday life.

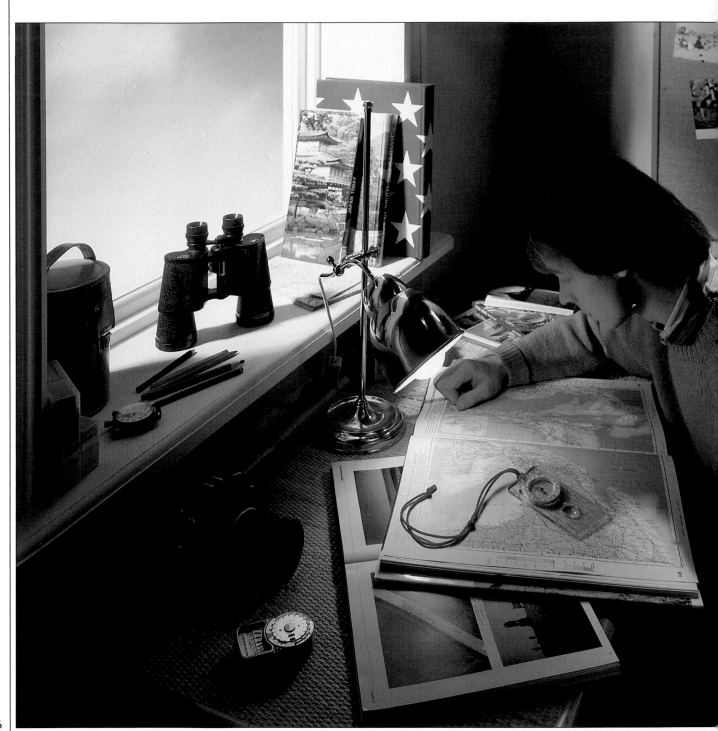

PLANNING A TRIP

Anticipation is one of the pleasures of travel. And with some advance knowledge of where you are going, you will waste less time in the wrong places and come back with a more interesting photographic record. Also, you will take better pictures if you have packed the right equipment. So before you leave, do some planning.

The first stage of preparation is to research as thoroughly as possible the places you will visit, using guides, travel books, brochures, magazines and postcards. Such visual material will provide a starting point for your own photographs. You should also find out what kind of weather to expect, if there are strict rules about access to particular sites, and the starting times of any special events to be held during your stay. For example, a nearby town might be celebrating a festival; or a night scene reproduced in a travel book may suggest a good subject for time-exposure pictures. All this research will help you decide what equipment is vital and what you can leave behind.

The need for planning does not stop when you get to a destination. If you are alone, you can work out a photographic schedule according to the subjects that appeal to you most. But if you are vacationing with friends or family, you will have to organize your photographic itinerary around your companions' plans. So try to arrange your more ambitious outings for the days when the others are indulging in more conventional amusements. For example, if you need to take a long, steep climb for an overall view of a resort, wait until your companions are relaxing on the beach, rather than drag unwilling hikers along with you.

A photographer studies maps to familiarize himself with locations for a planned trip. Around him are various travel books to aid his research, as well as some of the equipment he will take: a stopwatch for time exposures, binoculars, compass, camera and light meter.

What to take/1

Deciding how much film to pack is never easy – even professional photographers find it hard to predict the number of pictures they will take. How many rolls and what type of film you will need depends on your picture-taking habits and the variety of subjects that you are likely to come across.

To get an approximate idea of quantity, imagine spending a day at a colorful and photogenic occasion such as a carnival, and estimate how much film you are likely to need to make an adequate record. This may be anywhere between one roll and half a dozen rolls. Then for each week of travel, allow for one special day like this plus four or five days when you will use half this amount and one or two days when your camera is unused. Never take less than this in the hope that you will be able to add to the supply at your destination. The local drug store or even a camera shop may not have the type of film you prefer, and if you are going abroad, prices of film can be much higher than at home.

Film suffers from heat and humidity, so store it carefully. To save space, you may want to remove the rolls from their boxes and label the inner containers with the type or speed of the film inside. However, you should not remove the film from its airtight package until just before loading the camera, because the manufacturer packs the film in dry, dust-free air.

In hot, damp climates, leave film in a refrigerator, or in an air-conditioned hotel room, and take out only what you need for the day's pictures. Never leave film in direct sunlight or in a car on a hot day, where the temperature may easily go above 100 degrees Farenheit.

Choosing film
Keep the number of film types you take with you to a minimum. Decide first on color prints, slides or black-and-white. Within any category, your range of film should offer a choice of speeds for different subjects and lighting conditions, as the pictures at right illustrate. Medium-speed film (ISO 64 to ISO 125) suits most subjects, but pack a few rolls of faster film for pictures in low light or when you want to use a fast shutter speed. ISO 200 or ISO 400 would be a good choice. Many photographers also like to take some fine-grain slow film (ISO 25) for quality pictures in good light. As a reminder of which film is in use, you can slip a label from the pack into a holder on the back of some cameras, as on the one shown below.

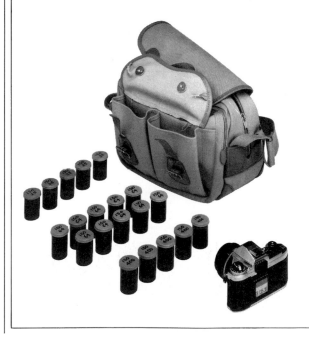

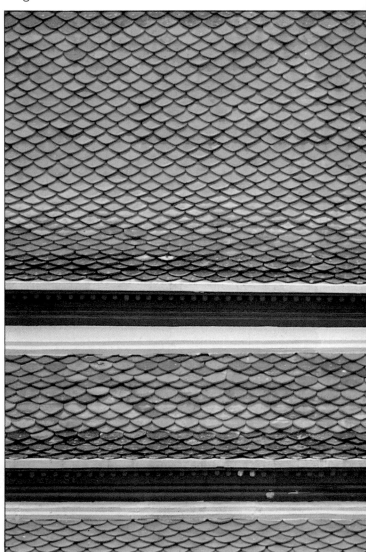

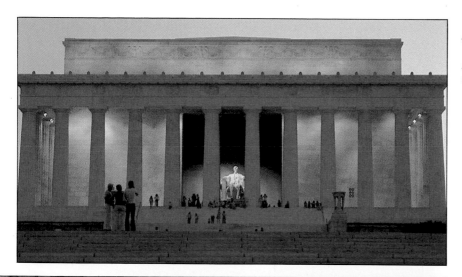

The Lincoln Memorial (left) glows with light in this late afternoon view. To take pictures in this light with a handheld camera, the photographer had to use fast ISO 400 film.

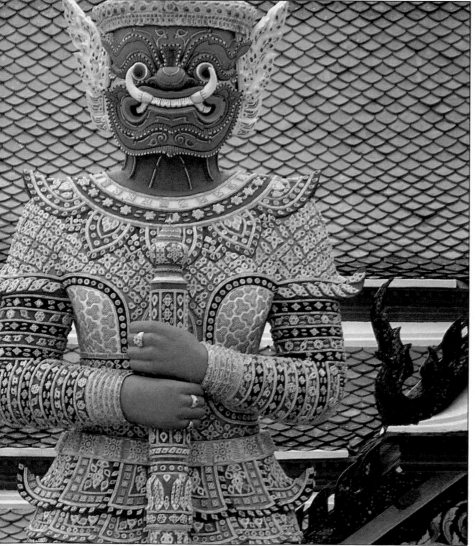

A huge statue (left) stands guard over a Bangkok temple, closely framed against an elaborately tiled roof by a 300mm lens. For a series of detailed studies of the temple architecture, the photographer loaded his camera with slow ISO 25 film, knowing that its fine grain would render the fine detail sharply.

Two Brazilian women (below) carry cooking pans on their heads. Working in good light and expecting to take a wide variety of subjects, the photographer could select medium-speed ISO 64 film.

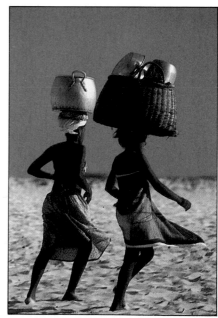

What to take/2

A full moon rises over a Mexican bay, silhouetting a rocky island against a silvery reflection in the water. Beyond, lights suspended over the stern of a fishing boat illuminate the nets. The idyllic scene seems perfect for a photograph, a special vacation moment. Yet it never reaches the film, for the photographer has forgotten to pack a tripod, and there is no suitable support nearby for the long exposure required. Such a missed opportunity shows the importance of care and forethought in selecting the equipment to take with you.

Ideally, you would have a full range of accessories when traveling. In reality, bulk and weight limit what you can take, no matter how extensive the equipment you have at home. Trying to carry more than is comfortable merely discourages you from taking pictures – a strong argument for keeping the selection simple. The items shown on these two pages comprise a limited selection from a standard range of 35mm equipment; they are chosen to be light and to fit into a small shoulder bag. The three lenses – wide-angle, normal and telephoto – are sufficient for most common situations, especially with the addition of a good-quality teleconverter to double the focal length. Note that this is matched to the lenses, to avoid loss of image quality.

Individual choices will differ according to special interests. For example, one photographer might want a macro lens or extension tubes for close-up shots, while another might like a longer focal length than the 200mm achieved by using a 100mm lens with a teleconverter. However, the difference in bulk between a 100mm and a 300mm or 400mm lens is important if you are going to do much walking.

A basic travel kit

A single camera, three lenses and a 2x (two-times) teleconverter, along with a few other accessories shown here, can cover many travel situations. By adding a good tripod, as illustrated on the opposite page, you will also be able to take pictures in extremely low light.

A lens shade is helpful, and essential in bright sun.

A lens cap should be fitted on each lens not in use.

The camera shown carries a 50mm f/1.8 lens, very useful in low light. All three lenses here have skylight filters to protect their front elements.

Two replacement batteries ensure an adequate charge for the camera's light meter.

A 2x teleconverter allows use of the 100mm telephoto lens as a 200mm lens and adds only a little weight.

A 28mm wide-angle lens (above) is useful for landscapes, interiors, buildings, crowds and people in their surroundings.

A 100mm telephoto lens is ideal for details and close-ups of faces, and also for views of distant landscapes.

Basic filters for color film are a polarizer (above left) to darken blue skies and a No. 81B to warm hues on dull days.

Minimum cleaning equipment consists of a blower brush (left) to remove dust, plus lens tissues to wipe glass surfaces.

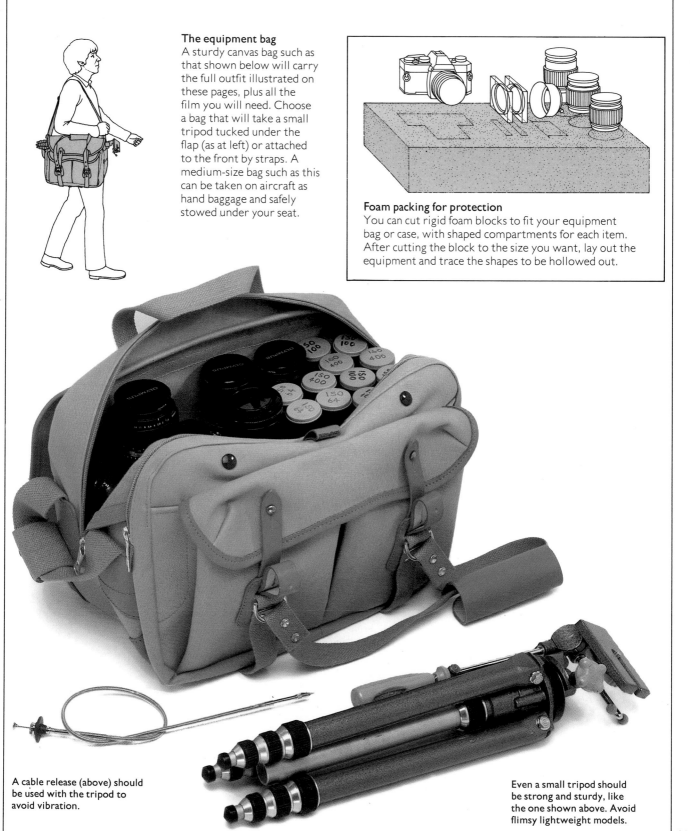

The equipment bag

A sturdy canvas bag such as that shown below will carry the full outfit illustrated on these pages, plus all the film you will need. Choose a bag that will take a small tripod tucked under the flap (as at left) or attached to the front by straps. A medium-size bag such as this can be taken on aircraft as hand baggage and safely stowed under your seat.

Foam packing for protection

You can cut rigid foam blocks to fit your equipment bag or case, with shaped compartments for each item. After cutting the block to the size you want, lay out the equipment and trace the shapes to be hollowed out.

A cable release (above) should be used with the tripod to avoid vibration.

Even a small tripod should be strong and sturdy, like the one shown above. Avoid flimsy lightweight models.

What to take/3

If you are planning a whole trip especially for photography, you may want to take with you more equipment than the ordinary travel photographer would carry. This allows you to cover not only the types of pictures you expect to take but also lets you respond to unexpected opportunities. For example, even if you intend to take all your pictures in available light, a situation may arise in which light from a flash unit is essential to catch the action – say a local celebration with open-air dancing after dark.

The range of equipment shown on these two pages is typical of what a dedicated photographer might carry to cover most eventualities. By taking two cameras you can use two types of film at one time and perhaps two different lenses for a quick response in changing circumstances. A second camera is also a valuable insurance in case one breaks down. The two models shown below accept the same interchangeable lenses. Several comparable good-quality systems are available.

The amount of equipment shown below and opposite is heavy to carry. Some soft camera bags can safely hold all the items, but when packed require a strong shoulder. A rigid equipment case is another possibility. Either way, you will certainly not want to carry everything at once when you are on foot in a strange town. A more practical solution is to have an additional small bag, as shown opposite. You can then use the large bag or case for transport and transfer what you need for a day's photography to the small shoulder bag.

A full-scale tripod, necessary for using the longer telephoto lenses, may present a special transportation problem. Unless you can fit the tripod through the flap or straps of a large camera bag, you may need to take a tripod bag. But in transit, the best place for the tripod is probably in your suitcase along with your clothing. For picture-taking expeditions, you can carry the tripod on a separate strap over your shoulder.

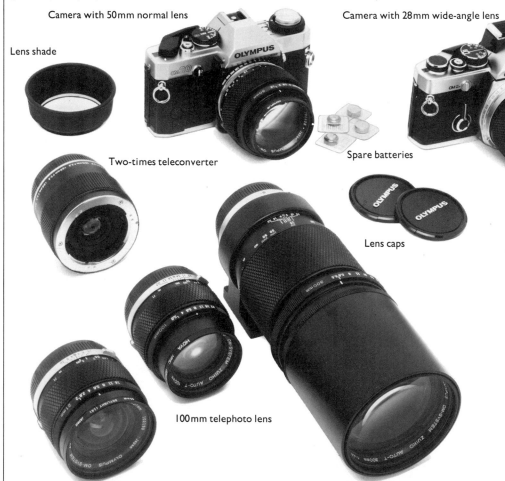

Camera with 50mm normal lens

Lens shade

Camera with 28mm wide-angle lens

Two-times teleconverter

Spare batteries

Lens caps

100mm telephoto lens

21mm wide-angle lens

300mm telephoto lens

A complete travel kit
With the accessories on the opposite page, two cameras plus five lenses will offer great versatility. The cameras shown above have automatic exposure with full manual override. Make sure you take spare batteries. The five lenses illustrated range from 21mm (suitable for panoramic views or for pictures in cramped interiors) to 300mm (a telephoto lens long enough for distant subjects). With the teleconverter, the 100mm doubles to 200mm. The 300mm doubles to 600mm, with slight loss of quality. The 50mm lens has a fast maximum aperture of f/1.2 for use in very poor light.

Camera cases
A metal case offers complete protection for cameras and lenses in transit. Choose one that is strong enough to stand on – thus giving you valuable extra inches when taking pictures in crowds. The shiny aluminum type at right offers good protection in strong sun by reflecting the light and keeping the interior cool. The small shoulder bag is enough for selected equipment when you are out on foot.

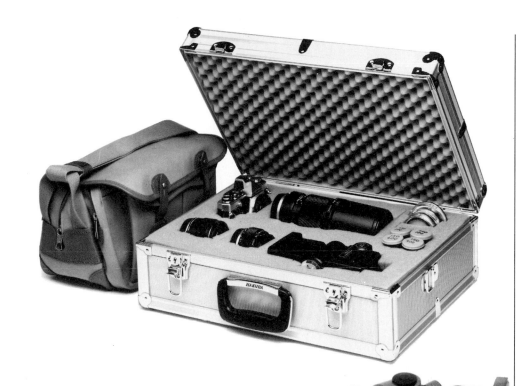

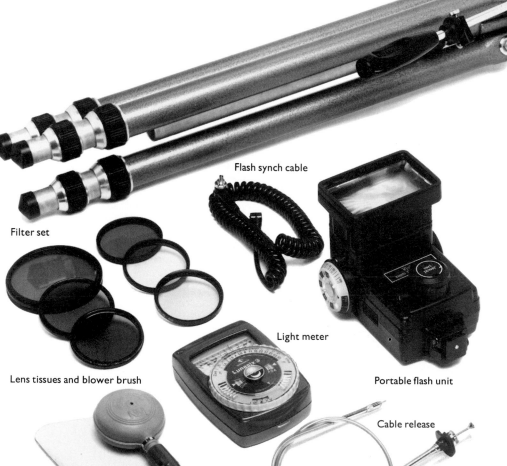

Tripod

Flash synch cable

Filter set

Light meter

Portable flash unit

Lens tissues and blower brush

Cable release

Accessories
A tripod is a key item of equipment and there is no point in trying to save on weight if you intend to use a long telephoto lens. The tripod here is quite heavy but not bulky. The set of filters includes polarizers for all the lenses – the large one fits the bigger diameter of the 300mm telephoto lens. In addition to the No. 81B "dull weather" filter, there is a No. 80B – for use in tungsten lighting with daylight slide film in the camera – and a yellow fluorescent filter for fluorescent light. A flash synch cable allows you to use the flash unit off the camera. The light meter can give greater exposure accuracy than does the camera's meter alone in dim interiors or in high-contrast surroundings.

23

Travel formalities

Camera equipment tends to attract special attention from customs authorities, particularly at airports. In some countries, the amount of equipment you are allowed to bring in is surprisingly limited, and if you are flying overseas with more than one camera and a handful of film, there may be problems.

Try to check the allowances beforehand with the tourist information services. In practice, customs officials have wide discretion over how strictly they enforce the rules. A reasonable, cooperative attitude will often work wonders. Remember that the regulations are generally designed to prevent people selling items at a profit without paying duty. Always stress that your cameras and equipment are personal effects. A good tip is to list cameras and lenses, with their numbers, so that the list can be registered with Customs, both when you leave your own country and upon entering a foreign one.

Alternatively, suggest that the details are entered by Customs on your passport so that you are obliged to take out the same items you brought in.

Another hurdle when you travel by air is the x-ray scan. X-rays can impair undeveloped film, especially fast film. Although a single, low dose may do no visible harm, the effect is unfortunately cumulative. If you have to change airplanes several times, subjecting your films to x-ray checks each time, the risk of spoiling your pictures increases. The best solution is to offer your carry-on bags containing film for hand inspection instead. If this is not possible, reduce the risk of x-ray damage by packing your films in the luggage you check. This is rarely x-rayed, unless there is an emergency spot check.

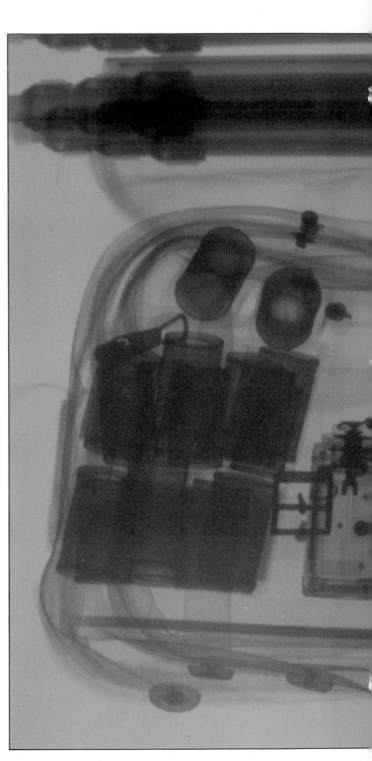

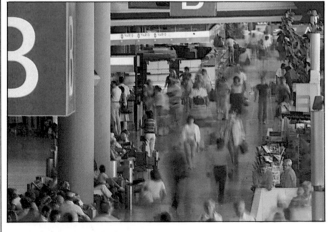

An international airport buzzes with life. While waiting for a flight, the photographer took this scene-setting picture from the high vantage point of a balcony, using a slow shutter to blur moving figures and suggest the bustle.

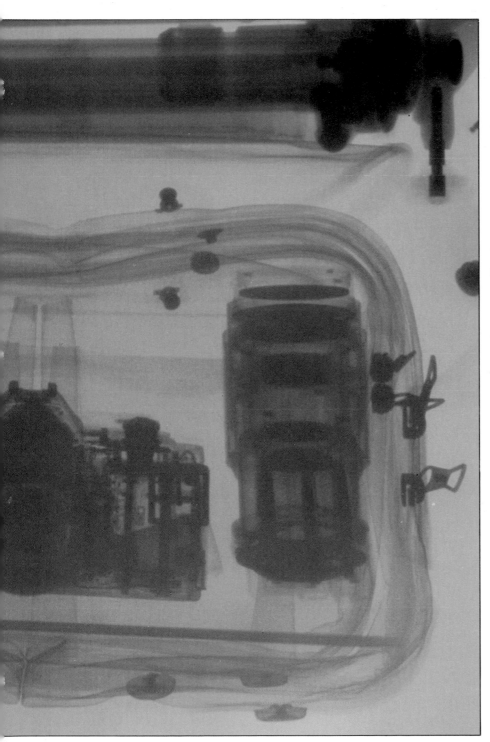

An x-ray photograph reveals the contents of a camera bag – including rolls of film.

A notice near an x-ray scanner warns of possible damage to undeveloped films. Many notices claim that x-raying does not harm film, but it is advisable not to take the risk if you can avoid it.

The effects of x-rays
The clips below are from a roll of film x-rayed for five minutes. This caused extreme fogging (unwanted exposure) with dark bars from the cassette. Successive bursts of briefer x-raying could cause damage too.

25

Camera ready

In a busy travel schedule, some of the best photographic opportunities turn up when you are least expecting them. Often a moment of magic is over in a flash. To capture images of spontaneous humor, such as the one below and those on the opposite page, you need to have a camera ready for immediate use – in your pocket or on a strap around your neck. Packed away in your luggage or even wrapped in its own soft case, a camera is of little use.

Besides making sure that your camera is accessible, there are other ways you can prepare for unexpected incidents and fleeting expressions. Keep the camera constantly set for the prevailing weather conditions and focused on a distance of eight to ten feet. If you have a moderately wide-angle lens, use it in place of a standard lens, because at an aperture of f/8 or f/11 – the normal settings on a sunny day – the depth of field of a 28mm or 35mm lens will extend from about four feet to 30 feet, making focusing unnecessary.

If you spot an interesting situation, such as the boys playing in the photograph below, quickly bring the camera to your eye and press the shutter release – do not hesitate or spend time trying to compose a beautiful image. After the first picture, there may be time to move in closer, or to recompose and improve on the first attempt. There will not always be a second chance, and sometimes you can improve a grabbed picture by good cropping at the printing stage, a procedure followed for the picture below.

Quick-reaction cameras
Fitted with a wide-angle lens, an SLR camera that automatically sets the shutter speed, such as the Pentax ME shown below, gives the photographer point-and-shoot convenience. If the light is bright enough to allow using an aperture of f/8 or smaller, most subjects will appear sharp at a focus setting of ten feet. Autofocus cameras such as the Canon Sure-Shot are even more convenient, because the controls are so fully automated that photographers are left free to react to whatever they see around them.

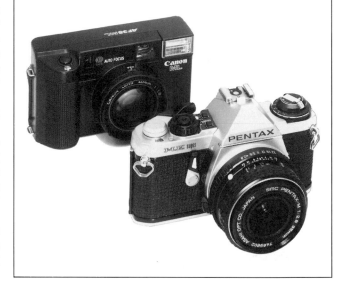

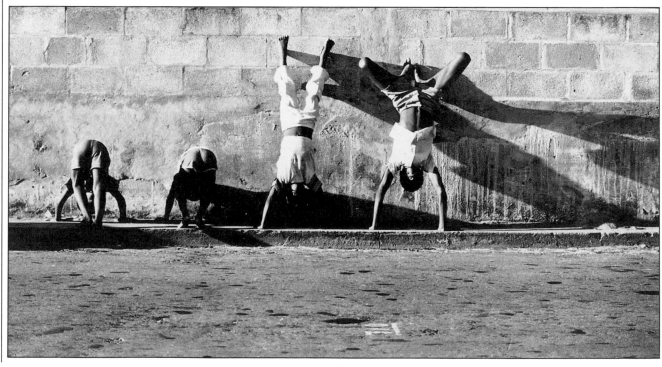

Guarding a villa in Los Angeles, a dog breaks the repetitive pattern of a balcony. In the bright sun, the photographer had preset an aperture of f/11, and the resulting depth of field allowed him to take the picture without focusing.

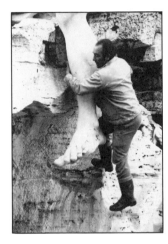

Losing his balance, a workman in Rome (above) clings to an unusual support and unintentionally makes an amusing puzzle picture. By using an automatic camera, the photographer was able to act quickly and catch the image on film.

Four boys on a New York street get an inverted view of the photographer, who used an autofocusing compact camera to record their antics instantly without attracting their attention.

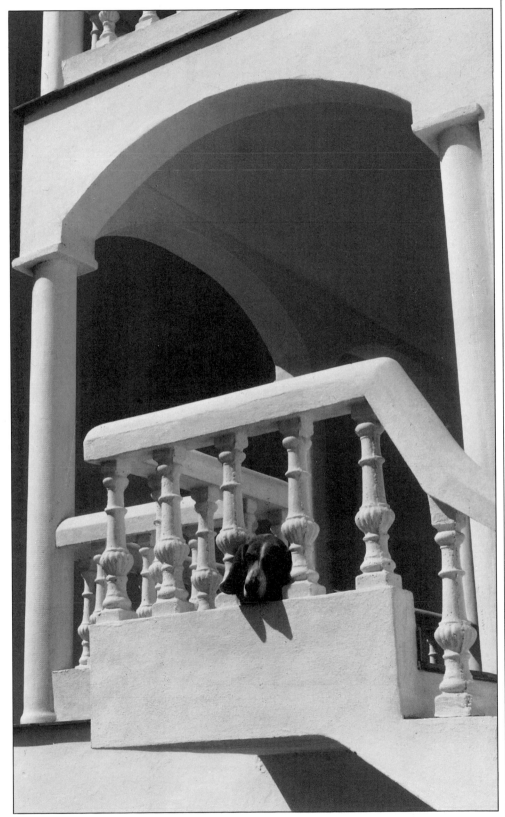

On the move/1

In an airplane, you can get original landscape views and also pictures that convey the heady experience of flying to faraway places. First, try to establish a good camera position on the plane. Check in early at the airport, and for landscapes get a window seat with an unobstructed view, farthest from the wings and engines. To reduce the effects of haze, reflections and window scratches, choose the side that in flight will face away from the sun.

Most commercial aircraft cruise at 30,000 feet or higher, and at such heights haze and clouds usually obscure views of the ground. For clear, detailed aerial views, take pictures shortly before landing or after takeoff, as in the photograph at right. Set the focus at infinity and select a wide aperture and a fairly fast shutter speed – at least 1/125 – to counter aircraft vibration. For extra clarity, you might use an ultraviolet or a polarizing filter. Keep the camera close to the window but not touching it, and avoid interior reflections by asking a companion to hold up a dark coat behind you.

At high altitudes, cloud formations or mountain ranges on the horizon provide interesting subjects, especially early and late in the day when there are spectacular lighting effects, such as in the photograph below, which was taken from an aisle seat during a night flight.

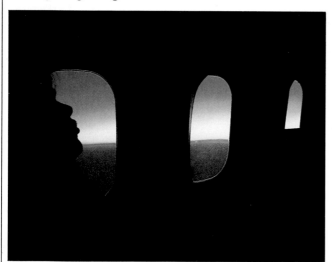

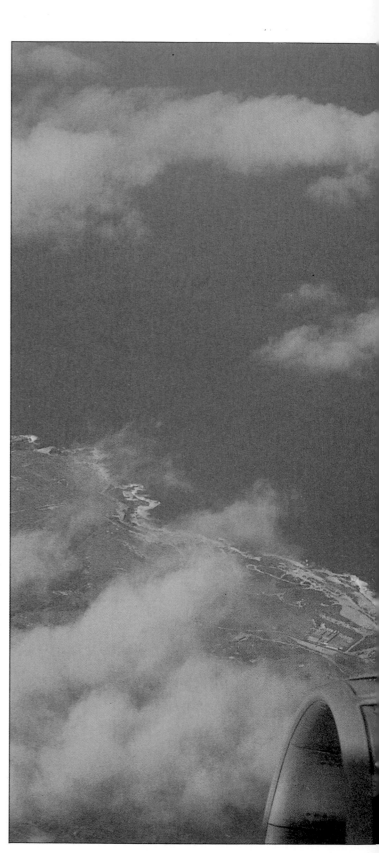

An airline passenger (above) sleeps as day breaks over the Atlantic. By exposing for the light at 1/125, f/11, the photographer recorded the interior as a solid silhouette, with the well-defined profile and the shapes of the windows adding interest to the composition.

Waves breaking along a coastline (right) are clearly visible through thin clouds in a view from a plane soon after takeoff. Photographing part of the aircraft, and a plane far below, effectively conveyed height and distance.

On the move/2

The slower forms of transportation, by land or water, enable you to record more effectively the physical experience of travel. Pictures of the changing scenery en route, the ports and stations where journeys begin and end – these convey the excitement and unpredictability of being on the move.

Sometimes, the mode of transportation uniquely characterizes a place, as in the graphic image of a San Francisco cable car, below. A large railway terminus or a subway station, on the other hand, can suggest the cosmopolitan flavor of a city. You might use a slow shutter speed to emphasize the rushing crowds at peak hours, as in the picture at near right, below. Late in the day, such places may be almost deserted. The few passengers on an empty platform at sunset, in the image at far right, convey the loneliness and long waits that are also part of traveling. Smaller railway lines often follow very picturesque routes on which you can record some fascinating scenes – as in the photograph at far right, below.

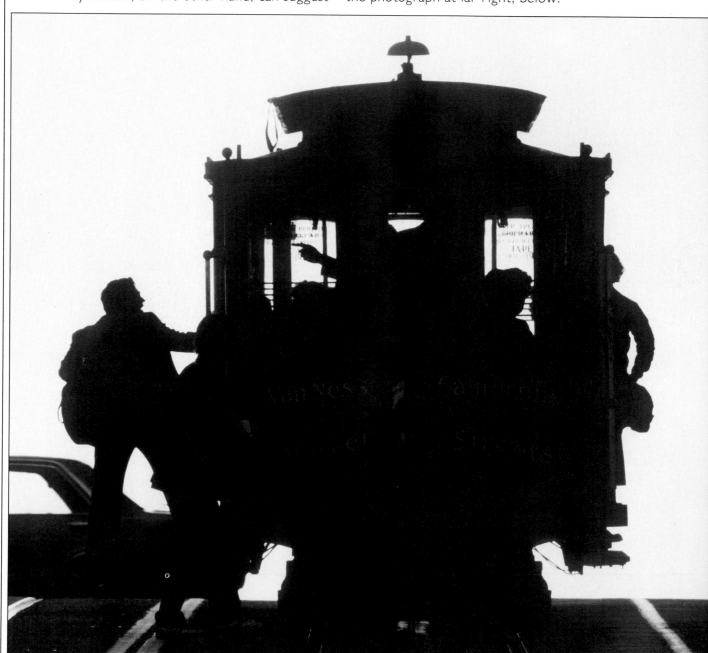

A cable car passenger in San Francisco alights on the crest of a hill. Strong sun directly behind made a dramatic silhouette of the car and the poised figure. The photographer used slow film and set a shutter speed of 1/125 at f/11.

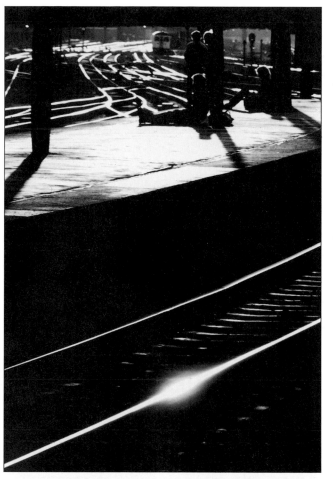

Weary travelers (left) wait for their train to pull in. The low sun, picking out the profiles of the figures and highlighting the weaving pattern of the tracks, made an atmospheric composition.

The twin funnels of a Mississippi steamboat (below) at New Orleans dominate the misty morning sky. The soft backlighting reduced the considerable detail in the subject to graphic outlines.

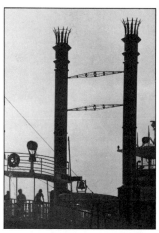

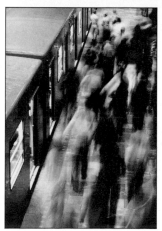

Passengers scurry along a busy subway platform in Mexico City. A shutter speed of 1/4 blurred the pedestrians to emphasize their bustling motion in contrast to the stationary train.

Overhanging leaves frame a view of a restaurant beside a rural French railway line. Grass growing up through the tracks helped to convey an impression of tranquility in this remote country scene.

Camera first aid

Modern cameras are commendably reliable, but nevertheless, breakdowns still occasionally happen. To minimize this risk, do not take a camera on vacation that has been left unused for some time. Instead, try it out before you go by shooting a roll of film. Replace the batteries with a fresh set, and take pictures indoors with flash, as well as outdoors. Try to use all of the shutter, aperture and focus settings, even those slow speeds such as 1/2 and 1/4 that you rarely use, then check the results.

Once you depart, if the camera jams or stops working for no apparent reason, the following checks may reveal the problem. First, look for the obvious. Make sure that the film in the camera has not run out, as this locks the shutter release. An incompletely pushed film-advance lever has the same effect, so check for this by cranking the lever – but do not force it.

If you have an aperture priority camera and the mirror appears to lock up, check that the camera is not simply making a long exposure because you are trying to take pictures in poor light with a small aperture setting. To release the mirror quickly, set the camera on manual or on the flash synchronization speed – marked with an X. If the mirror seems jammed, try cleaning the camera's batteries with an eraser, or replace them. Clean the camera contacts too, as these can corrode, sapping the power.

Operate the shutter at all settings. Listen for the sound indicating that the shutter speed is changing.

Check that ISO dial is set to the correct film speed.

Routine maintenance
Common-sense precautions can help to prevent camera jams and damage, particularly in dusty or humid conditions such as those shown in the pictures at top right. At the end of each day and when you finish a film, run through the cleaning routine and series of checks annotated on the illustrations at right and opposite right. And if you can, regularly check the camera's meter by comparing readings with another camera or with a handheld meter.

Blow dust off front and rear of the lens, then wipe off grease and fingerprints with a rolled-up lens tissue. Keep a skylight filter on at all times.

To check the meter, attach the lens, and set the aperture to f/16. In bright sun, the shutter speed and film speed should almost match. Thus, with ISO 64 film, the meter should indicate about 1/60.

If the focusing screen and mirror get dirty, clean them carefully with a soft brush.

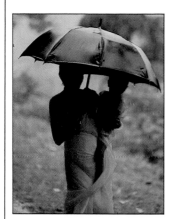

A tropical rainstorm (left) created the risk of water damage, so the photographer put the camera in a plastic bag with a hole for the lens.

A dust storm (right) in the Finger Lakes area, New York, presented the photographer with the risk of dust jamming the camera. He taped over all gaps on the camera body and avoided changing the film or lens during the storm.

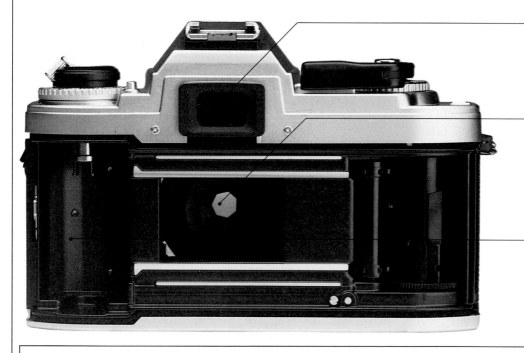

Clean the viewfinder window with a cotton swab.

Open the camera back and operate the shutter with the aperture set to f/16. Watch the iris diaphragm to ensure that it closes correctly.

Brush dust from film spool and cassette chambers, and remove film fragments, which can easily jam the shutter.

If power fails, try removing batteries from the compartment on the camera baseplate and cleaning the terminals with a typewriter eraser.

Emergency repair kit

For making repairs while on vacation, pack a small kit. Compressed air, lens tissues, cotton swabs and a brush are all useful for cleaning grime from camera and lenses. The abrasive point of a typewriter eraser removes any oxidation from batteries and terminals. In case of power failure, take spare batteries and a coin to open the battery compartment. To seal a damaged camera, pack rubber bands and black tape. The film can is a light-proof container for exposed film.

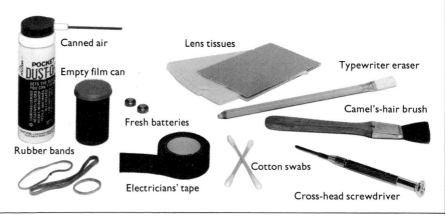

Canned air

Empty film can

Lens tissues

Typewriter eraser

Camel's-hair brush

Fresh batteries

Rubber bands

Electricians' tape

Cotton swabs

Cross-head screwdriver

Local research

However well you prepare the ground for a trip before leaving home, there is no substitute for on-the-spot research. The more information you can glean from local sources, the more chances you have of finding unusual viewpoints or rich photographic source material. The pictures on these pages all resulted from using local knowledge.

Begin with published information – guides, maps and postcards from bookshops and kiosks at stations, airports and hotels. Studying postcards is

particularly useful: you can put yourself in the photographer's position, and then consider other possible viewpoints and approaches. Next, visit the local tourist office and travel agents. There, you can get free, up-to-date literature and detailed information on subjects that interest you. A list of organized tours, even if they are too expensive or not to your taste, can be helpful when you plan your own excursions.

Finally, remember that your best sources are all

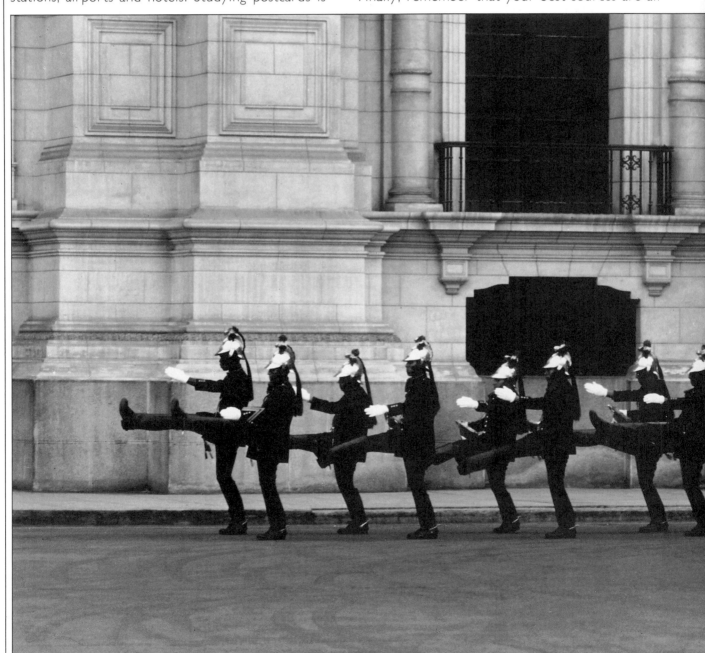

around you: the local people. Never hesitate to ask, and ask again. A sound policy is to ask several people the same question, because not all the information you receive will be reliable. The staff at your hotel or guest house will usually be very helpful, but if possible take the precaution of checking out what they tell you at the photography site. For example, to find out when fishermen return with their catch – as in the picture at right – make your inquiries at the harbor.

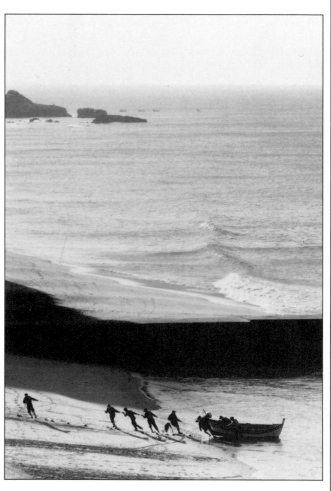

Peruvian guardsmen (left) kick high in rigid unison during a march past the presidential palace in Lima. The photographer found out the time of the ceremony and had his camera ready to catch the perfect moment.

Portuguese fishermen haul their boat ashore (right). Locals told the photographer when and where the catch came in. She chose a high position to achieve the well-balanced composition.

Rio de Janeiro (below) nestles in its bay. The usual view is from the top of Sugar Loaf Mountain. But guided by a local, the photographer obtained a stronger image from a position halfway up.

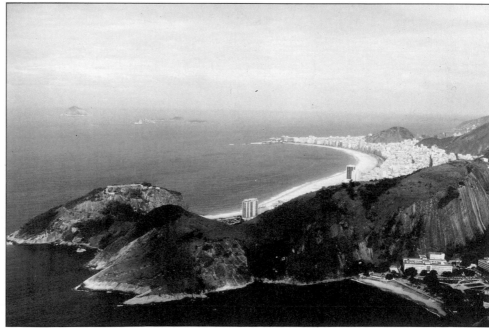

Judging a location

Once you have researched a locale and have a clear idea of the subjects you want to photograph, you should consider the best conditions for taking your pictures. Of course if you are recording an event, timing, and to a certain extent camera position, will be predetermined. But for more stable subjects — scenic views and interesting landmarks or buildings — the time of day and the viewpoint you choose are all-important, as illustrated here.

The first step at any site is to make a reconnaissance visit. If time and the site permit, walk around the subject to assess every possible angle. Make running notes of the advantages and disadvantages of various approaches, and try to imagine how changing lighting conditions will affect each view. Again, postcards of the subject will provide useful comparisons. Deciding when and how to take the picture will depend on what you want to convey about the

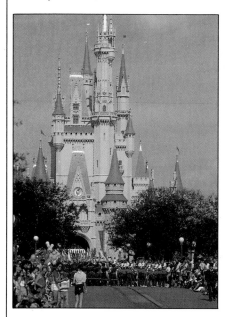

Cinderella's Castle in Disneyworld, Florida, forms a backdrop for a colorful parade (above). The photographer chose to concentrate on the holiday atmosphere of the scene, taking the picture in bright light and using a 105mm telephoto lens to make the castle a prominent subject.

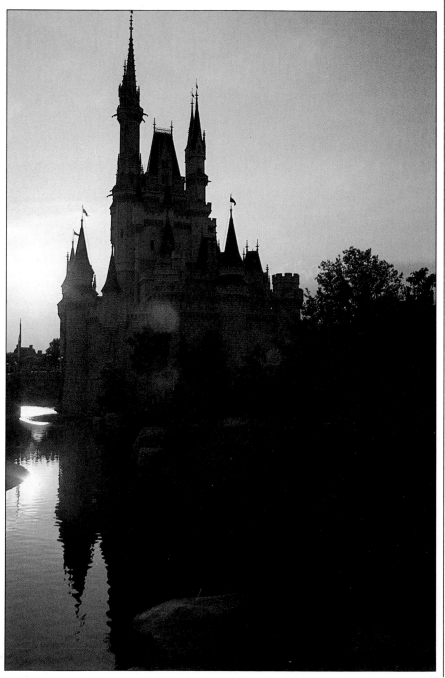

Outlined against the sky at sunset (right), the castle takes on a fittingly fairytale appearance. This picture evokes a romantic mood largely by means of backlighting from a low sun, which has cast warm reflections onto the walls of the castle and the still water beneath.

place, and whether or not you want to include other elements in the composition. For example, the photographer of the picture at left on the opposite page made the castle the setting for a vibrant street parade in brilliant sunshine. The second picture shows a quite different approach: the photographer used the sunset to create a mood of fantasy.

To help you to choose the most effective lighting conditions, find out both the time and the direction of sunrise and sunset; these will depend on the season as well as the place. Remember that the angle and quality of early light change very quickly; arriving at the site even ten minutes late may mean missing the best picture. You may also need to take the weather into account. Where the climate is consistent, you can plan your pictures precisely. Otherwise, be prepared to visit a site several times until conditions are right.

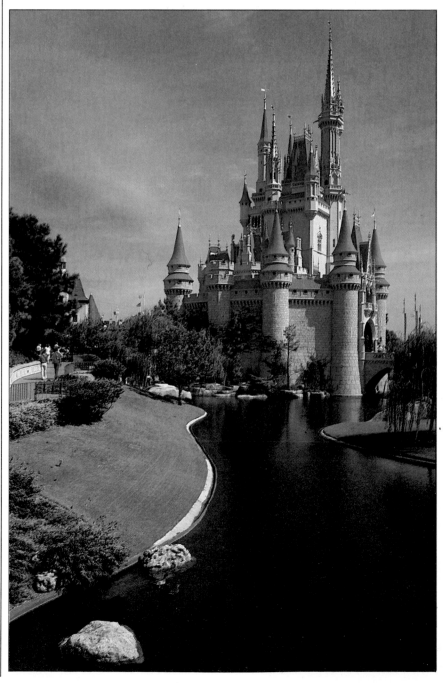

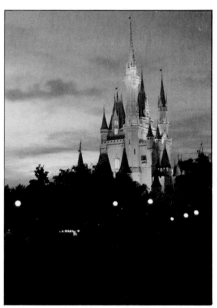

A nighttime view of the floodlit castle (above) produced a contrasty image with a strong theatrical quality. The photographer set a slow shutter speed of 1/60 at f/4 and used the light patterns made by globed streetlights to balance the uniform darkness of the foreground.

In late afternoon, lengthening shadows and oblique, raking light reveal the texture and form of the castle. The selection of a fairly distant camera position encompasses the whole tranquil setting, with the meandering course of the water leading the eye to the subject.

37

Keeping a record

Pictures taken on vacation are likely to be more numerous and varied than in any other situation. Try to make a habit of keeping notes about your photographs at the time you take them. This will be helpful whether you simply want to identify your pictures or to use captions or a commentary that will add interest when you display them.

However vivid your experience of places and events, relying on memory alone is risky if you are taking a lot of pictures of different locations. Even the strongest recollections become blurred in the time lapse between taking a trip and having your pictures processed. And nothing is more frustrating than being faced with mystery prints or slides, particularly if they are among your best images.

To make a reliable record, all you need are a notebook, a pen, some means of labeling film as you complete each roll, and a simple numbering system. When you take a photograph, write down the number of the frame and next to it the place, date, time of day and other details of interest about the scene. You might want to note an original viewpoint or include exposure details if lighting conditions were unusual. When you unload film, label the cassette with a number or date and then note it alongside the details of the photographs. When you have films processed, ensure that they are all separately identifiable. After the developed pictures have been returned, caption the slide mounts or number the prints to correspond with your notes.

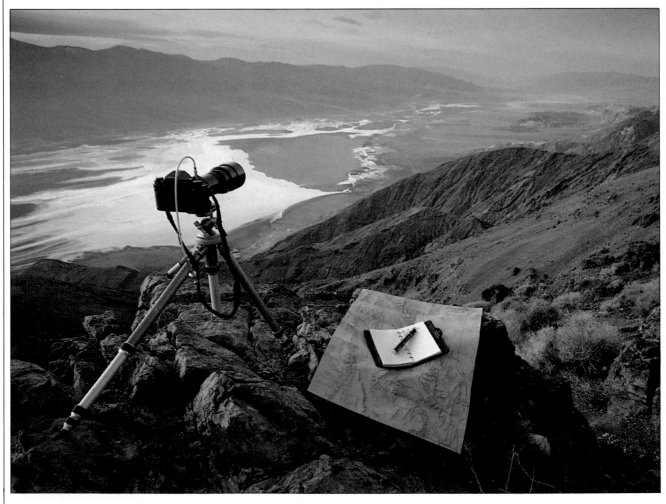

The rugged scenery of Death Valley provides a superb subject for landscape photographs. To identify each scene – here, Dante's View – the photographer used a local map and logged the details of successive pictures in a notebook.

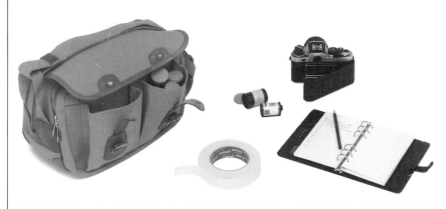

A simple reference system
The basic equipment for keeping a photographic record fits easily into a camera bag. List details of every shot in a notebook; a loose-leaf type will enable you to insert extra pages for captions if you wish. Use adhesive tape or labels to number or date each roll as you remove it from the camera. Write the film number or date next to the appropriate caption notes for future reference.

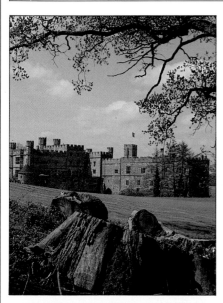

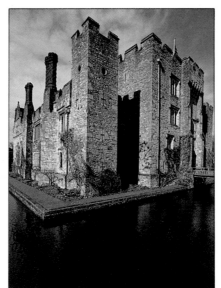

The four photographs at left, of castles in southern England, were all taken during the same trip. But if viewed weeks later, the images could have easily been confused. By jotting down the name of each castle, as well as details about the view and other elements in the scene at the time he took the picture, the photographer made sure that he could identify them. From left, clockwise, are Leeds castle, Hever castle, Dover castle and Sissinghurst castle. With subjects such as these, covered fully in guide-books, brief visual clues to the image are usually all you need note. Thus, for the picture of Leeds castle at top left, noting the facade shown, together with a mention of the tree stump, would identify the shot.

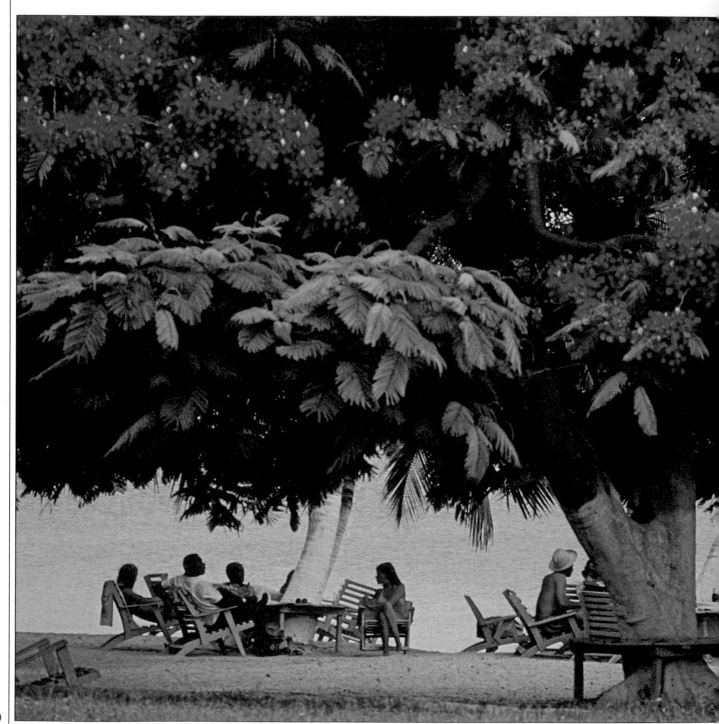

THE HOLIDAY CHALLENGE

Holiday photography usually has to fit into a full timetable of pleasure activities. With a wealth of subject matter and a limited time in which to cover it, there is a tendency to take hurried pictures and to try to cram as much as possible into each one.

The key to successful vacation photos is to exploit the qualities of a particular location. Lighting and climate, setting and the type of trip you are taking will all have a bearing on the approaches and techniques you use. At the seaside or on a winter sports vacation, bright sun and simple, graphic scenery enable you to record colors strongly and details sharply. However, with open landscapes and seascapes, you may need to introduce a dominant point of interest to avoid blandness. In cities and towns, the opposite applies: you will have to make a conscious effort to isolate one subject from the distracting surroundings. Wherever you are, be selective. A photographic record of a vacation should do two things – convey the personal and individual experience of a trip, and capture the spirit of a place and people. Rather than try to combine these two aims, concentrate on one aspect at a time. And remember that carefully chosen details, such as the trees providing a focal point for the scene at left, often result in more telling images than do all-inclusive views.

The spreading branches of poinciana trees heavily laden with blossoms provide a glorious focus for a scene in Haiti. Rejecting an obvious beach view, the photographer stood back to fill half the frame with the trees and show the vacationers in a small area of light.

The shore/1

Sea and sand, favorite ingredients for a vacation, are also a magnificent setting for photographs. But pictures of your trip companions posed against a background divided into equal areas of sky, water and beach can have a predictability that palls. The images here show three approaches that break away from such conventional seaside snapshots.

One possibility is to treat the subject as an abstract composition. In the picture at right, the rows of beach umbrellas casting dense shadows on the sand make a colorful pattern as well as effectively conveying the mood of a vacation. From the same high viewpoint, bathing huts or deck chairs might provide similar compositions. A beach crowded with people may produce a cluttered image, if you are standing on the shore. For the picture below, the photographer moved behind the beach and used a climbing frame in the foreground to give the image strength and individuality.

The time of day you choose to take your picture can make a tremendous difference to the most ordinary subject. The photograph on the opposite page is an example. On a sunny day, the distant figures set against a plain expanse of blue would have lacked interest. By waiting until evening, the photographer obtained a marvelously atmospheric image.

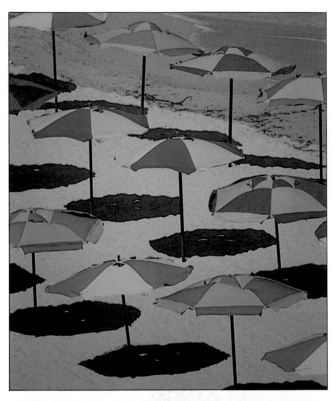

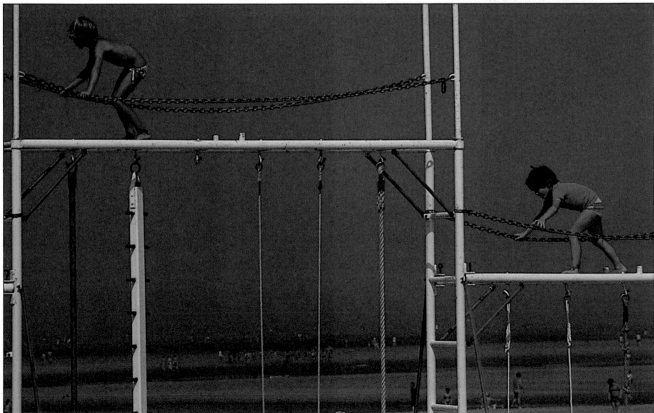

Gaily colored umbrellas
(left) line the sand at a
European beach resort.
The photographer waited
until the beach was empty
and the sun created solid
shadows on the pale sand,
and selected a high diagonal
viewpoint to make the most
of the strong color pattern.

Children (left) clamber
across a jungle gym above
a French beach. Focusing on
the foreground elements
produced a lively, balanced
composition. The clean white
lines break up the large
areas of blue and provide
a frame to view the distant
vacationers on the sands.

Young Californians
frolic in the waves at the
end of the day. Noting the
beautiful pastel colors of
the sky and sea, and the
shadowy backlit figures, the
photographer set a very slow
shutter speed of 1/4. As a
result, the swirling motion
of the water is exaggerated,
and movement partly dissolves
the images of the subjects.

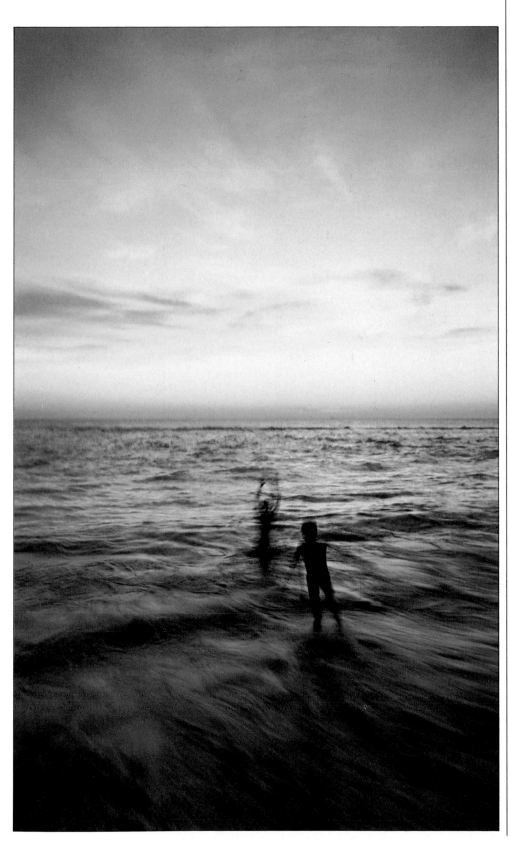

43

The shore/2

The shifting colors and movement of the seashore make it a scenic subject in its own right. In the course of a single day, a seaside view will change enormously in character. The water's surface, in particular, alters dramatically according to the lighting conditions, from a limpid turquoise when the sun is at its zenith to a sparkling wash of mauve and gold at dawn and sunset.

To capture a pathway of light on the sea at evening, aim your camera toward the sun's reflection and bracket your exposures. Use a telephoto lens to fill the frame with the glittering highlights, or a wide-angle lens to record them as mere pinpoints of light. In daylight, beach views can easily appear bland and empty, however picturesque the scene before you. This is particularly true in bright sunlight, which will

A palm tree *spreads a giant shadow across a Florida shore. From a position overlooking the beach, the photographer noticed the graphic pattern made by the fronds' shadows on the smooth sand. The unusual foreground interest perfectly conveys the mood of a sub-tropical scene.*

Fishing boats *(right) with their lights aglow off the coast of Thailand stand out against a silken sea bathed with the colors of dusk. The photographer chose just the right moment to take the picture, when patches of light breaking through the clouds balanced the grouping of the vessels.*

have a flattening effect on the scenery. So try to find some element of interest – rocks perhaps, or a small island – that will give the picture a focal point.

Trees lining the beach can provide a silhouetted foreground frame for a view. Look too for patterns in the form of shadows, which will show up graphically on the pale, even surface of the sand. The picture below at left shows how use of a foreground shadow can enliven a conventional seashore view; including the palm tree itself would have produced a much less interesting photograph. At the beginning and end of the day, the colors of the sky reflected on the water will add dramatic interest, as in the photograph below. These often wondrous displays last only briefly, so have your camera ready to seize the moment.

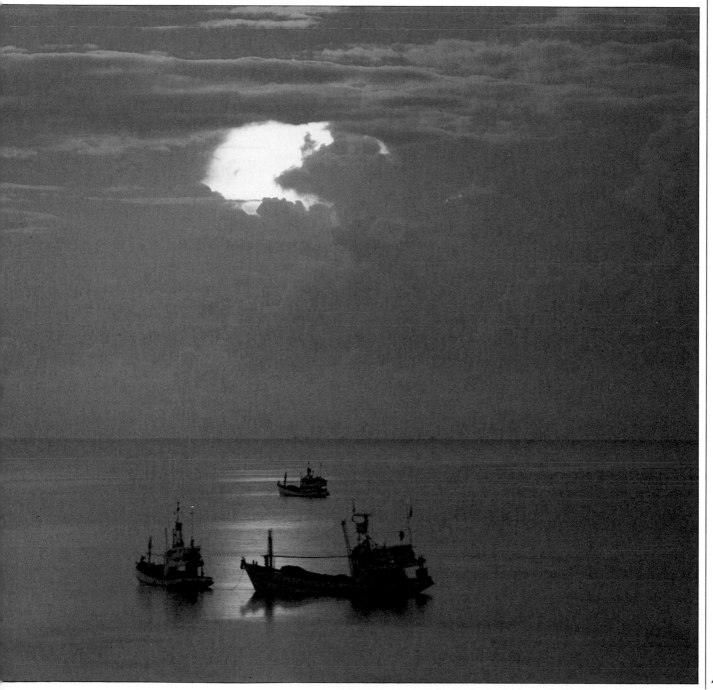

Below the waves

Underwater photography involving deep diving is a specialized skill. But you do not need to go far beneath the surface to take fascinating pictures of marine life, using a snorkel and face mask, and some simple means of waterproofing your camera, as illustrated on the opposite page.

Without flash, clear water and good light are essential. Try to choose a time when the sun is at its height and the sea is calm: even slight ripples will reduce the amount of light reaching the camera lens. Load your camera with fast film – ISO 400 or Kodacolor VR1000 – and set a wide aperture to make the most of the light. Avoid pointing the camera directly downward, or the image will look flat. If you shoot from below, pointing toward the light, you can get strong, silhouetted shapes, perhaps including part of a boat, some tall coral, or shoals of fish. Judging light levels is difficult underwater, so automatic cameras are preferable.

With scuba gear, marine photography becomes more exciting. But technical problems increase as you go deeper: not only is there rapid fall-off of light, but colors are progressively filtered out until only blue remains. As a result, an underwater flash unit becomes essential. Because even clear water contains fine particles that bounce light back, you will need to hold the flash off-camera to prevent a speckled effect from overexposing those particles close to the camera. For the best results, use a wide-angle lens and get close to the subject.

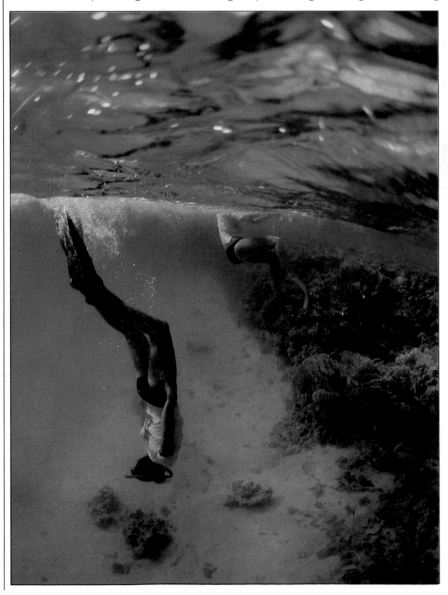

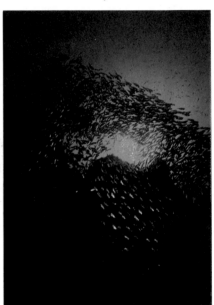

Myriad tiny fish (above) mill around a rock in search of plankton. The photographer pointed his camera toward the light to silhouette the more distant fish against the blue water, and fired a flash off-camera to highlight the shoal nearest to him, in the shadow of the rock.

Snorkelers (left) explore the clear waters of the Caribbean. From just below the surface, the bright sun enabled the photographer to take the picture using available light. He loaded fast film and set a shutter speed of 1/125 at f/11.

Gliding fish pass a fan of coral (right) in tropical waters. The dim light at a depth of about 30 feet made flash lighting essential. Closing in on the subjects with a 20mm lens gave clear detail and good depth of field.

Underwater camera equipment
1 – A soft vinyl bag sealed with a clip has a rigid porthole for the lens and an inner glove to operate the camera. Such bags suit most cameras and may be used to a depth of 30 feet.
2 – The inexpensive 110-format all-weather camera is easy to use for snapshots in shallow, clear water.
3 – A rigid acrylic housing protects your camera at scuba-diving depths and allows full flexibility.
4 – A special camera such as the Nikonos is the best; it performs well even at a depth of 150 feet.

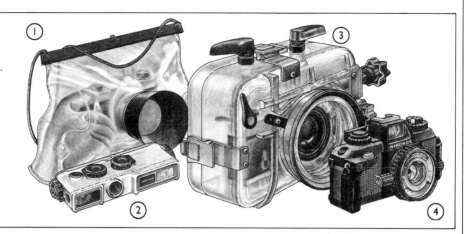

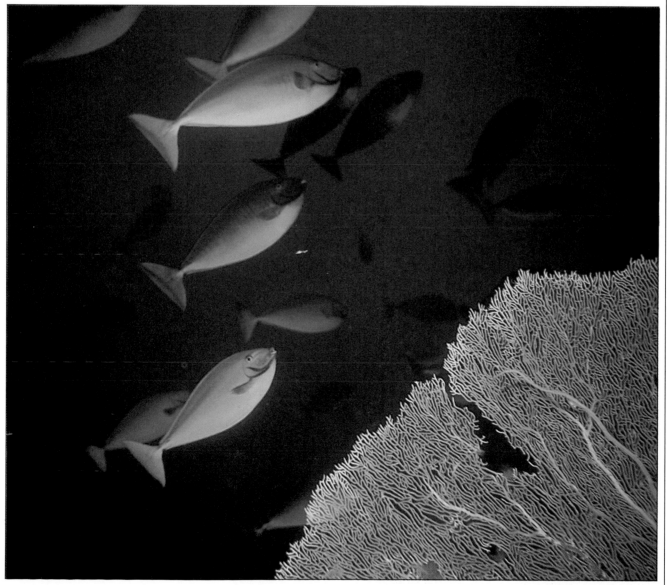

Vacations afloat

From the deck of a boat you gain views of the sea, shorelines and other craft that are completely different from those you can see on land. Usually the location is greatly simplified. Set purely against the blue and white of water and sky, a colorful object – such as the yellow sail in the picture at right below – has added graphic impact.

However, a bland expanse of sea occupying a large area of the foreground may easily appear dull and featureless. Try to take pictures when weather and light conditions create color and movement on the water. For example, a low sun helps to provide contrast between brilliant reflections and long shadows. With a higher sun, too much reflection may make the sea look gray and flat. A polarizing filter will cut down the glare and bring out the sparkling blue of the water.

When your boat puts into harbor, you can take advantage of the mirror-like reflections in calm water to create interesting effects, as in the picture of moored yachts at right. Out at sea, if there is nothing of interest on the horizon, concentrate on the activity on board. In these circumstances, when space is limited, a wide-angle lens is particularly useful and will enable you to include more of the subject in the frame.

Camera care at sea

Saltwater, in the form of splash or spray, can cause serious damage to camera equipment. Even a fine salty mist may have a corrosive effect. Listed below are some simple precautions that will protect your camera.

* Keep all equipment in a case when not in use.
* Use a skylight filter to protect the camera lens.
* If spray is a risk, put the camera in a plastic bag with only the lens uncovered; seal with a rubber band.
* If equipment is splashed, wipe it dry at once then clean with a cloth dampened in fresh water or rubbing alcohol to remove any salt deposit.

A solitary sail (right) *dips behind swelling waves off Hawaii. The photographer spotted the harmonious color composition and center-framed the sail, using a polarizing filter to reduce reflections on the water and increase color contrast in the sky.*

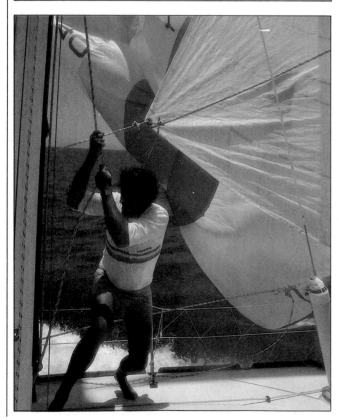

A yachtsman (left) *hauls on a line to hoist a sail. By using a 28mm lens, the photographer could include more of the complex detail. Light behind the billowing sails deepened the colors.*

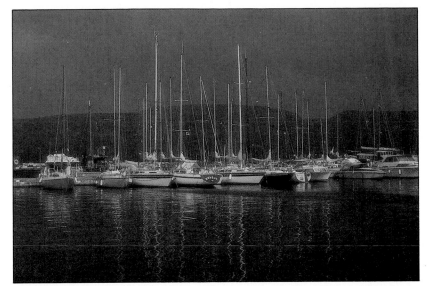

Yachts nestle *at a quay on an overcast day. Taking advantage of the dull light and a low sun, which threw shimmering reflections of the masts on the dark, still surface, the photographer deliberately underexposed to exaggerate the effect.*

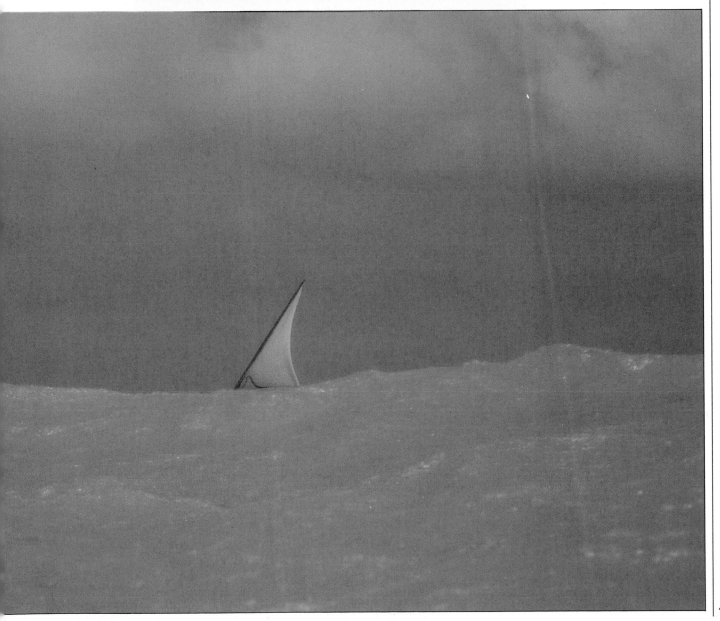

The wilderness

National parks and other wild places possess an elemental beauty that can be visually overwhelming. The photographer's instinct is often to point the camera randomly and hope that the scenery will do the rest. But capturing the majesty and scale of a wilderness is surprisingly difficult.

A view that includes mountains in the background requires careful composition and choice of lens. For example, a normal lens may produce images that look disappointingly insignificant; if you want to convey the impressive height of distant mountain peaks use a telephoto lens, which will bring the background forward dramatically. When the outline and structure of a cliff are important, try to choose a time when the angle of the sun throws the subject into sharp relief. The view of the Grand Canyon immediately below shows how these lighting conditions can define shape and texture.

A wide-angle lens gives greater scope to the scene opposite, emphasizing the bowl shape of the valley and the clear expanse of water. Such a lens is also useful if you want to close in on foreground details, as in the picture at the bottom of this page.

Spectacular scenery in Banff National Park, Alberta, Canada, is mirrored in the glass-smooth surface of Lower Consolation Lake. A 35 mm lens brought the clear foreground reflections into sharp focus.

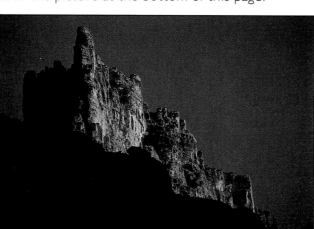

Rock formations at the Grand Canyon (left) take on the appearance of an ancient citadel against the evening sky. The photographer closed in with a 200 mm lens, and chose a viewpoint to obtain the full effect of the low, raking light on the rockface.

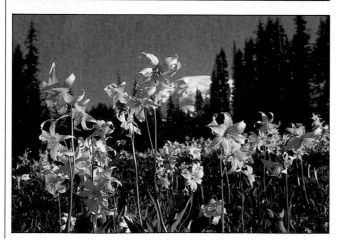

Lilies (left) lift their heads to clean mountain air in Olympic Park, Washington. Moving in, the photographer used a 28 mm lens at its full aperture – f/2.8 – to make the flowers in the immediate foreground stand out in crisp detail against an unfocused backdrop of trees.

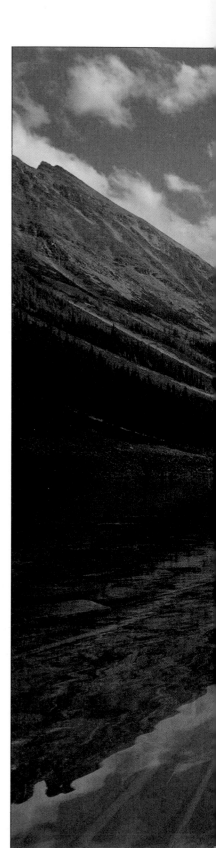

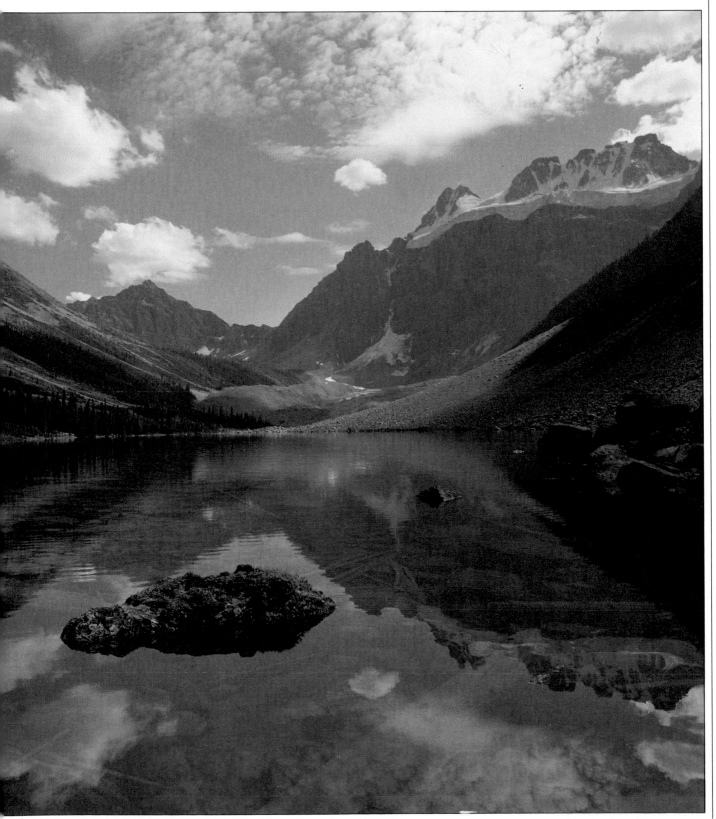

Backpacking

Many of the most marvelous wild places to photograph are accessible only on foot, and experienced backpackers will tell you this is the only way you can really experience the wide open spaces. On foot, you certainly become part of a landscape in a way that is impossible even in a jeep. The view of Guatemalan mountains below suggests the sense of wonder such close communion with nature can evoke. Hikers themselves can also be included, as in the picture on the opposite page, where the tiny figure both suggests the hardships of the environment and gives the image its sense of bizarre scale.

The weight of equipment is a crucial factor when you are a backpacking photographer. Suggestions for carrying and protecting cameras are in the panel at right. Before you set out, decide what equipment will be strictly necessary and exclude everything else. For example consider whether just one moderately wide-angle and one telephoto lens might be enough without a normal lens as well. Zoom lenses can be useful in extending the range of choice without adding bulk. Although you will need some kind of camera support, an ordinary tripod may be awkward to carry. One solution is to take a tiny tabletop tripod, but a folded jacket placed on a rock may do just as well.

Carrying equipment

Knocks and scrapes can be a major risk to cameras and lenses in rough terrain. The illustration at right shows useful precautions that will not impede your movement. Put in a small backpack the equipment that you do not need immediately. Spare film and an extra lens can be neatly stowed in a hip-bag. Sling the camera around your neck, but wear an elastic strap that will hold the camera against your chest and prevent it from swinging against rocks as you walk.

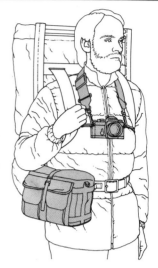

A patch of farmland in hill country (below) takes on the colors of the evening sky, photographed with a 135mm lens looking down from a viewpoint on a track into the mountains.

Floating ice (right) makes an awesome backdrop for the lone figure of a boy in California's Sierra Nevada. A 300mm lens compressed the perspective to create a dramatic contrast of scale.

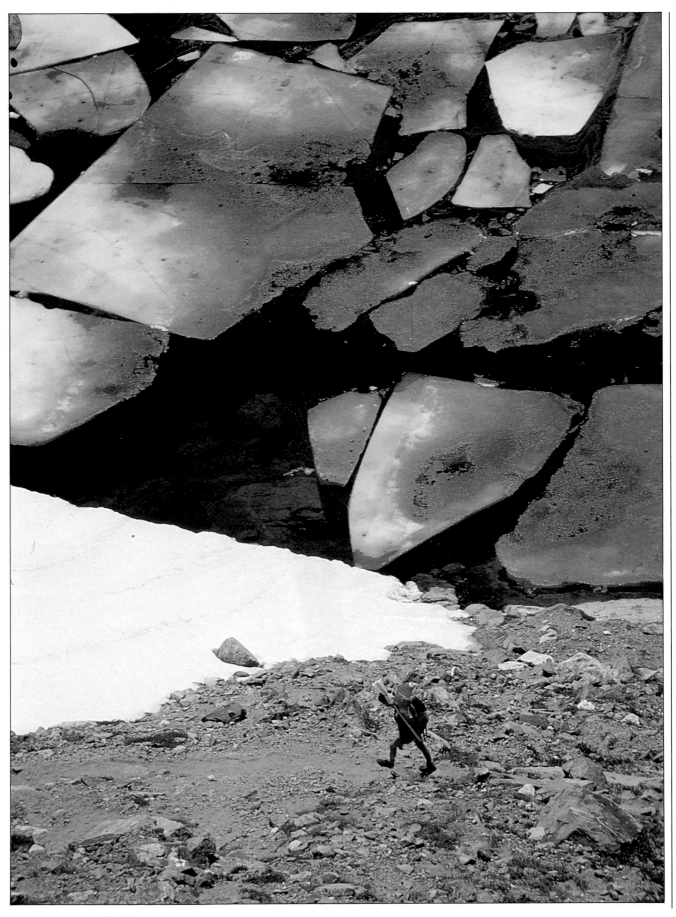

Snow and sun/1

A winter vacation offers an exciting change of perspective for photographers. Landscapes and street scenes take on a stark simplicity with fallen snow creating crisp patterns, unexpected shapes or a background for vivid color contrasts.

In very cold conditions, special precautions will help safeguard your equipment and film. The box on the opposite page outlines the most important of these. In moderately cold weather, cameras function normally enough; however, in snow you need to take special care in judging exposure. To record the whiteness accurately, you should deliberately overexpose by one or two stops any scene in which snow is the dominant element.

Falling snow presents a special problem, because nearly always the sky will be heavily overcast and the light dim. In these conditions you will need to have fast film in the camera and use wide apertures, as a shutter speed of at least 1/125 or 1/250 will be necessary to stop the snow streaking. Of course you may want to use the streaking effect deliberately, as in the picture at top right, in which case a speed of 1/30 or 1/60 is appropriate. Another trick is to use an on-camera flash to arrest falling snow and create a speckled effect on the film.

In overcast weather, use a No. 81B filter to prevent a blue cast from appearing in your picture. If there is a blue sky and your subject is entirely in the shade, a filter with a stronger yellow color – such as a No. 81C – is a better choice. However, if the subject is at least partly sunlit, as in the pictures below, no filter is necessary.

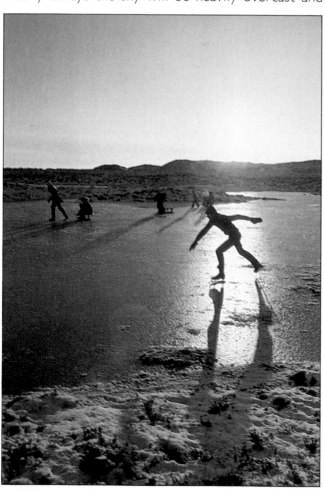

The winter playground of a frozen lake needed a focus of interest to make an effective picture. The photographer faced directly into the setting sun and waited for a skater to cross its gleaming reflection, overexposing by one stop.

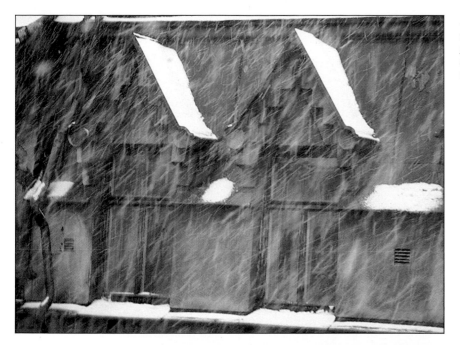

Falling snow eddying past gabled windows in Stockholm makes an evocative picture, taken from a hotel room across the street. A shutter speed of 1/30 streaked the snowflakes crisscrossing the image.

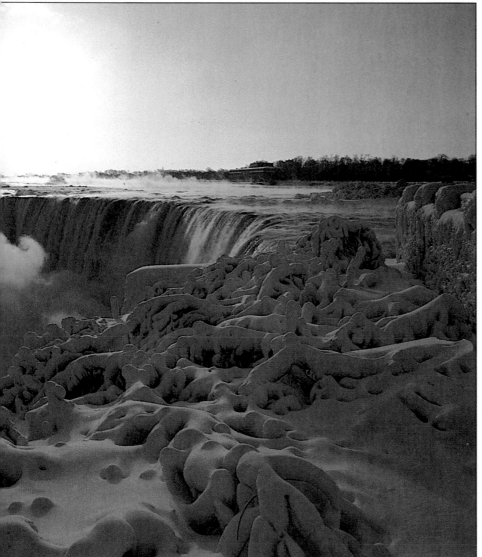

Cold weather precautions

In cold, dry weather, keep the camera warm under outer clothing. But in blowing snow, let equipment cool down so that flakes do not melt and freeze again, jamming the controls.

Carry spare batteries in a warm inside pocket in case those in the camera lose power as a result of the cold.

In extremely cold conditions, film becomes brittle, so wind gently, and do not use a motordrive.

Rewind film slowly so that sparks of static electricity do not fog the film.

Avoid breathing on equipment, because breath condenses and forms ice.

Before bringing a cold camera indoors, wrap it in a plastic bag, as condensing moisture can cause damage.

Cover metal camera parts with fabric tape, or they may stick to bare skin.

Bracket exposures to guard against cold-induced meter inaccuracies.

The splendor of Niagara Falls gains extra impact from the snowy banks and from a viewpoint that looks directly into a low sun. Careful composition excluded footprints that would have spoiled the impression of pristine crispness.

Snow and sun/2

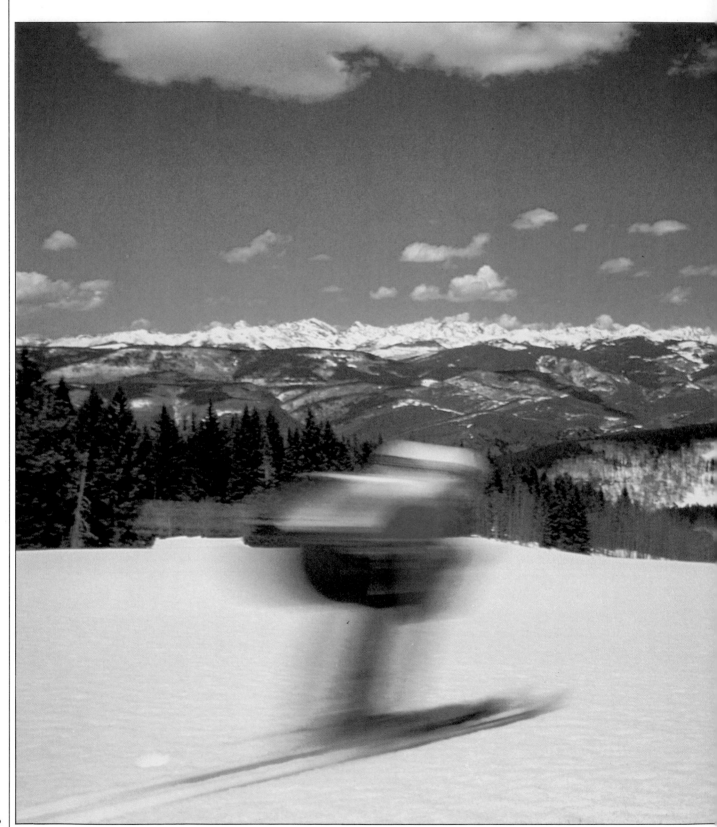

A lone skier at Steamboat Springs, Colorado, blurs at a shutter speed of 1/30. The photographer darkened the sky with a polarizing filter and exposed normally.

Heading uphill, two cross-country skiers (above) cut tracks through the snow. The photographer would normally have overexposed because snow dominated the picture. But here the sun created extremes of contrast, so he exposed normally and thus preserved the fine texture of the sunlit snow.

Most people visit winter sports areas for the dual pleasure of crisp, snow-covered scenery and exhilarating activities shared with friends or family. But for the best photographic results you must decide which of the two elements should predominate.

In the picture at far left, the photographer concentrated on the panorama of sky and mountains, and used a small aperture and a slow shutter speed to record a passing skier as an impressionistic blur. The picture below demonstrates the opposite approach — a wide aperture has blurred the background and highlighted the expressions of the skiers as wind gusts into their faces at the top of a run.

To capture snow scenes at their most attractive, photograph them early or late in the day when the low sun rakes across the snow, as in the picture of cross-country skiers at near left. At these times, the light catches ridges or ski tracks so that they stand out brilliantly etched. And if you want to reduce glare and make a blue sky contrast dramatically with the white of the snow, use a polarizing filter.

Not all winter activities produce pictures that are so alive with color and movement as those of skiing, and in static situations the framing of the background becomes important. For example, by filling much of the frame with the surrounding mountains in the image below at left, the photographer has given his fishing scene an atmospheric grandeur.

Patient fishermen wait at holes cut in the ice of a Wyoming lake. A 135mm lens compressed the perspective, making the landscape seem even more imposing.

Starting off, a group of friends at Val d'Isère, France, leave the ski-tow behind. Slow film (ISO 25) is ideal for capturing all the color of bright mountain scenes.

Local sights

Every city, town and vacation resort has its own special places – a beautiful church, a square or perhaps a spectacular view. For the traveler, such local landmarks always merit a visit, and usually at least one photograph. But a place that has obvious scenic attractions is often more difficult to photograph satisfactorily than one in which you have to search out a view that appeals to you individually. The sense of discovery is missing, and without this a photographer's response can easily become jaded.

One way around this problem is to turn away from the more obvious attractions and take a slightly more oblique view. Often you can achieve an element of visual surprise simply by being selective instead of trying to make an instantly recognizable picture by including everything. Start by standing in a position that gives a broad general view, and look for single aspects of a place that give it individuality and character. This is the approach that the photographer took for the picture at far right of twin skyscrapers in New York towering above an old church. Having identified this interesting juxtaposition, the photographer found an original viewpoint.

An unusual viewpoint of this kind can often help to break out of the mold of convention. Pictures taken from very high up, such as that of St. Mark's Square in Venice, at right, or from low down at ground level, may make even a much-photographed place look unexpectedly different. Or you could try using a long telephoto lens and photographing a landmark from a very distant location. The modification of space and perspective produced by the lens forces the viewer to see the essential character of a place or building afresh.

Try to avoid taking pictures in the middle of the day. Instead, return in the late afternoon or early morning, when long shadows rake across the ground, as in the view of St. Mark's. Dawn and dusk can be spectacular times too, as the sky turns deep blue and streetlights add a warm glow to the scene.

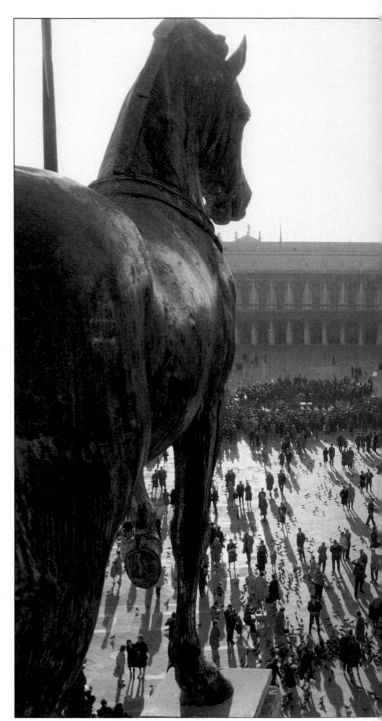

Bronze horses *frame the crowds filling St. Mark's Square, Venice, in this wide-angle view. Most pictures of the scene show the horses from ground level, but by climbing to a viewpoint between the statues, the photographer neatly reversed this tradition.*

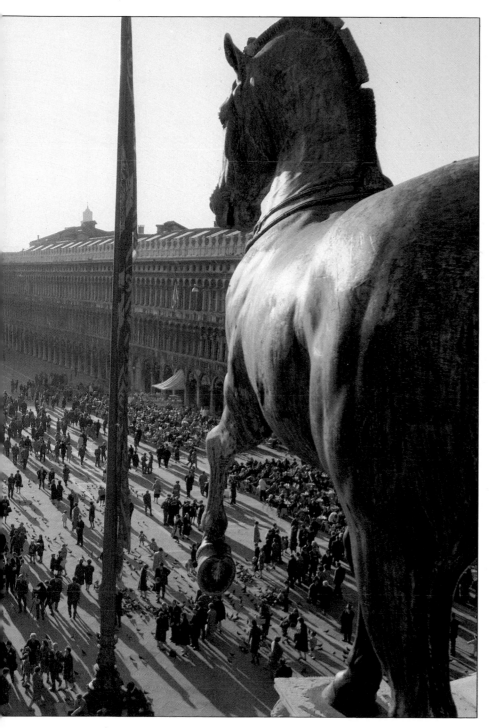

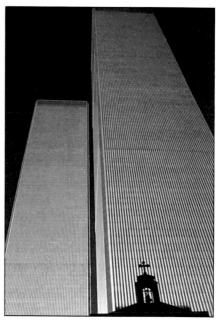

Two white towers soar into the sky, which the photographer has darkened by using a polarizing filter. Expecting an effective picture from the high contrast between the bright building and dark belfry, she followed the low meter reading of 1/125 at f/8 on her medium-speed ISO 64 film.

Nightlife

Nightlife offers some of the best views of cities and resorts. For example, Las Vegas looks unexciting under the hard Nevada sun, but at night the city glows with millions of lights and becomes a subject for glittering pictures such as the one below at right.

A few simple techniques will allow you to capture the pulse of life indoors at restaurants, nightclubs and shows. Flash is often prohibited and if allowed tends to produce harsh results, so use a fast film, ISO 400 or ISO 1000. A lens with a wide maximum aperture – at least f/1.8 – is also an advantage.

To take effective outdoor pictures of city lights, both a wide-angle lens (say 28mm) and a moderate telephoto lens, in the range 105mm to 200mm, are useful – plus a tripod and a cable release. With a tripod, ISO 64 film should be fast enough. Use day-light-balanced film as color imbalances are irrelevant amid a multicolored mixture of garish neon signs and streetlights

Downtown areas are usually full of visual interest. With the wide-angle lens, look for colorful views full of lights, perhaps with some foreground interest such as the car in the Las Vegas scene. With the tele-photo lens, you can select details of neon signs or move farther back for the kind of graphic picture shown on the opposite page. In either case, use the tripod and also bracket exposures because of the difficulty of judging the light. As a general guide, bright scenes will require an exposure of about 1/8 at f/2.8 with ISO 64 film.

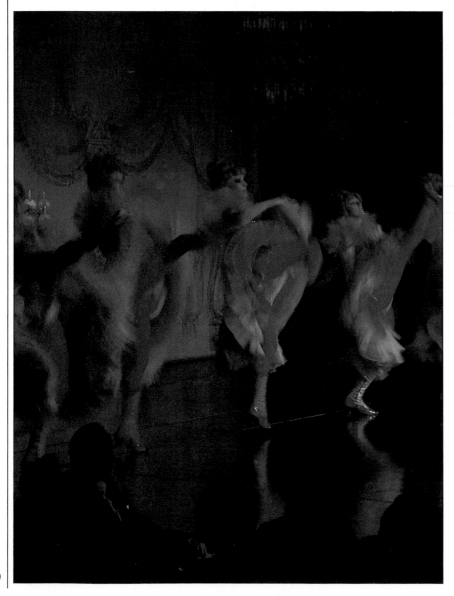

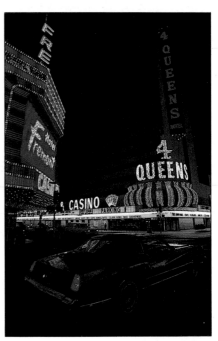

At a Las Vegas intersection (above), a car reflects the dazzle of neon lighting. With such strong light in the scene and a 24mm lens at f/2, the photographer could use a speed of 1/30 with ISO 64 film.

Nightclub dancers (left) go through a can-can routine. ISO 160 tungsten film showed the natural colors of the stage lighting with an exposure of f/2 at 1/15.

Fountains (right) silhouette a row of seated figures. The photographer used a 200mm lens from across New York City's Lincoln Plaza, and included the spotlit painting inside the building as a backdrop (ISO 64 film: 1/8 at f/4).

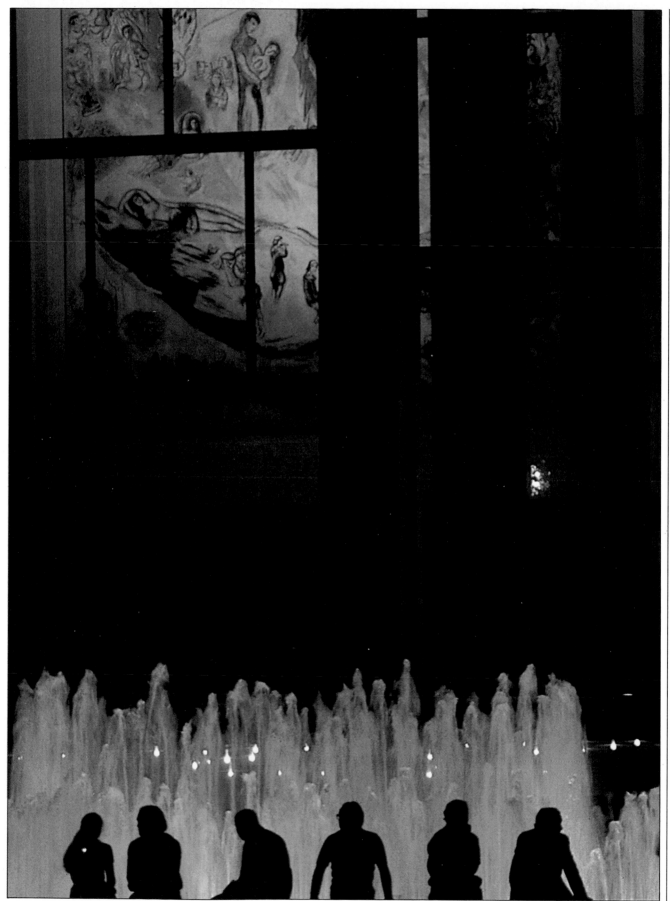

Carnivals and processions

With some preliminary research, you may be able to plan a travel itinerary so as to take in the colorful spectacle of a carnival or street festival. Forward planning also helps on the day of the event. Usually, there will be an organizer who can advise you on the route and timing of the parade and suggest the best vantage points.

Try to visit the possible viewpoints beforehand so you can decide which lenses you will need. Street parades always attract large crowds. Unless you can arrive early, a high position that allows you overall views clear of the spectators' heads is often the best. Someone with a house or shop along the route might let you photograph from an upper window or balcony. But if you have to stay at ground level, an aluminum camera case or even a box to stand on will give you extra height.

Decide in advance whether to maintain one position or to move around. If you are staying put, take as much equipment as you think you might need. Otherwise, limit your equipment to what you can carry quickly and easily. Above all, aim for variety. The photographs on these pages show how you can either concentrate on the general atmosphere or pick out an interesting detail, to obtain quite different images of a single event.

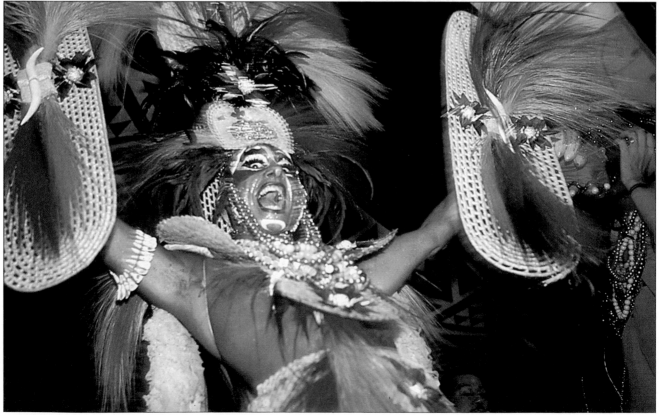

The embroidered coat of arms of a state trumpeter prompted an unusual image of the Lord Mayor's Show in London. By tight framing with a 135mm lens, the photographer used this detail to suggest the historic ritual.

Jaunty shire horses draw the Lord Mayor's coach through the City of London. A 200mm lens enabled the photographer to capture this delightful moment.

Costumed dancers (above) throng the streets of Rio de Janeiro at carnival time. To convey the festive chaos of the scene, the photographer found a high vantage point and selected a slow shutter of 1/30 to blur movement.

A carnival character (left) performs a dance with manic glee. The photographer used flash to bring out the details of the costume and isolate this one spectacular figure from his surroundings as a float passed by.

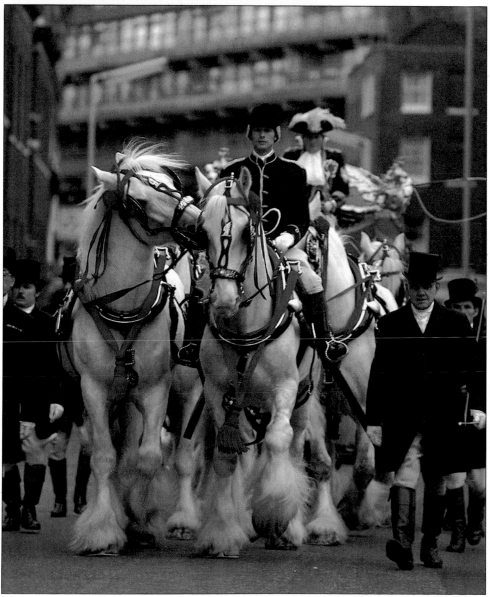

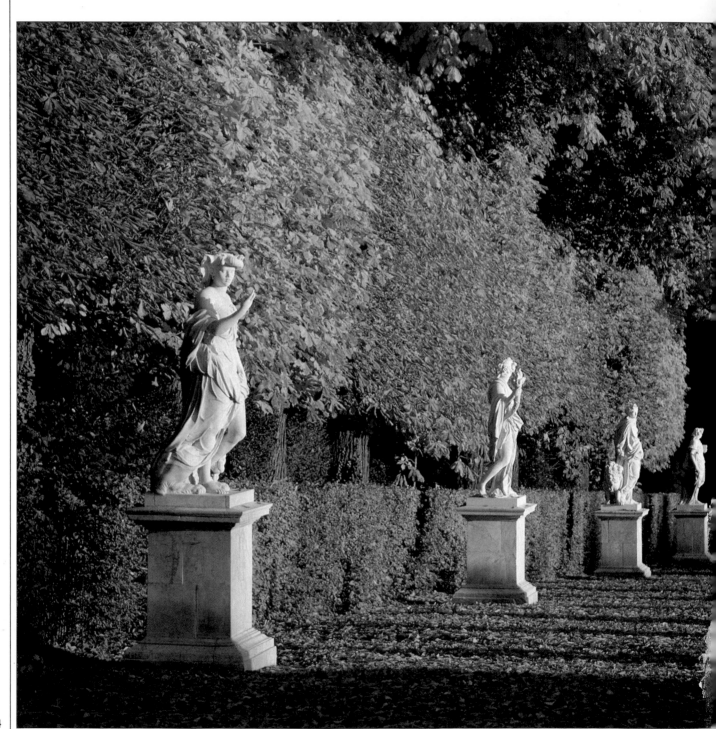

A FEELING FOR PLACES

The best travel photographs have in common the ability to convey strongly the character of a place. This is not simply a matter of including some recognizable feature in the viewfinder – the Golden Gate Bridge in San Francisco or Notre Dame in Paris. An important ingredient is the photographer's own awareness of being a traveler and of experiencing different air and light, unfamiliar sights, smells and sounds. What travel does is to sharpen all our senses so that we notice things instead of looking at them with eyes dulled by familiarity. For a travel picture really to work, it has to capture some of this heightened awareness.

The first requirement is to be receptive to the mood of a place and to your own feelings about it. Then look for a telling image or an evocative effect of light that may express how you feel. For example, the picture at left shows an avenue at Versailles, from which Louis XVI and Marie Antoinette were taken to Paris at the outbreak of the French Revolution. The quietness, the autumn colors and the empty vista beyond the shadows seem to take us down a time tunnel so that we catch some faint echo of the past, as the photographer must have done when he composed the picture. Only by finding an individual point of view can you communicate a sense of being in a place.

A row of statues lining a walk in the gardens of the Palace of Versailles seems caught in a moment of eerie stillness. To evoke the mystery, the photographer took the picture late in the day, when the sun cast long shadows, first waiting patiently until no visitors appeared in the viewfinder.

Developing a theme

The pictures on these two pages were all taken in Venice, the city of canals. They show how a single idea or visual element, in this case reflections in water, can lend continuity to travel photographs. By developing such a theme you can also introduce an element of personal interpretation.

Try to decide first what you feel is unique or most significant about a location. Take a little time to explore and get to know your subject. You can combine this process with researching the best views to photograph, but the aim should be to form a general impression. Then look for a way to translate your idea into pictures with a simple visual element that you can repeat and develop – not in every single photograph but in a proportion of them. If your choice of a theme is apt, you will be surprised at the number of visual opportunities it opens up.

Thematic ideas are best kept simple. For example, the coexistence of old and new in a place famous only for its archaeological remains might suggest as a theme pictures of ruins with modern advertising signs deliberately included in the foreground. Other ideas could be the variety of crafts practiced in a location, or the village-like pockets of individuality that survive in some of the biggest and most anonymous cities.

A woman at her housework (above) *seems to waver in the summer heat. In fact, the photograph shows a reflection in the mirror-like surface of a canal on a bright day, with the picture printed upside down. The photographer focused on the reflection with a 105 mm telephoto lens.*

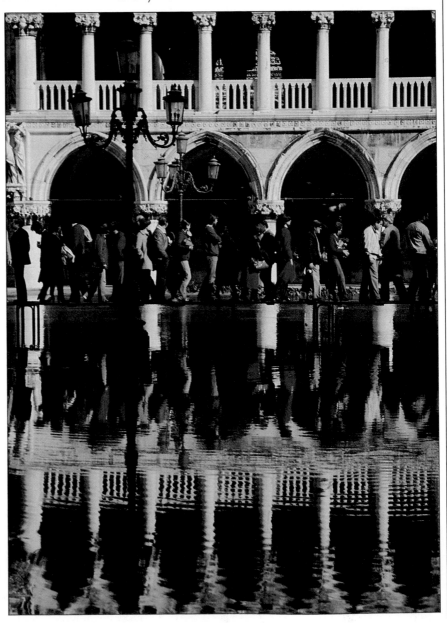

Pedestrians cross a cat-walk (right), *placed over the flooded pavement of St. Mark's Square. A 200 mm lens emphasized the walkers and their reflection, with the bold architecture of the arcade of the Doge's Palace as a backdrop.*

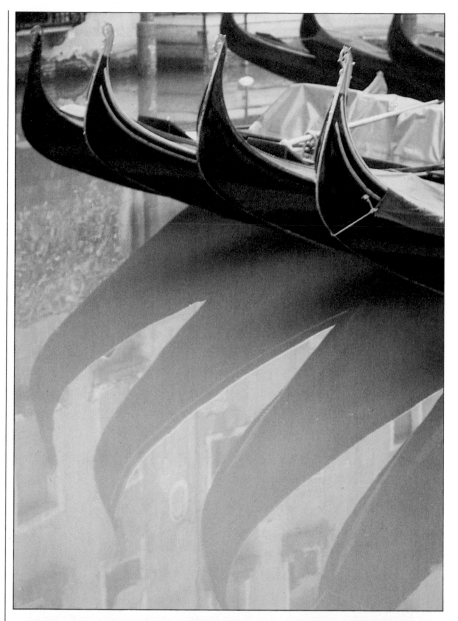

Gondolas stand idle *(left), their distinctive shapes repeated in the misty reflection. The photographer used a 135 mm lens to concentrate on the graphic qualities of this detail.*

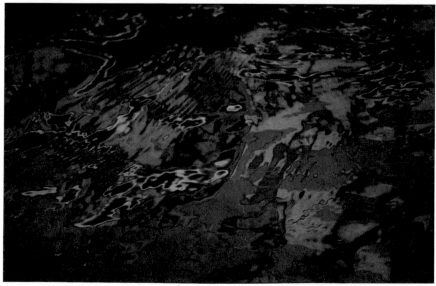

Ripples of color *(left) fill the whole picture, with no recognizable element to give a clue to the scene's location. Yet this abstract image makes an expressive addition to a series portraying the moods of Venice. The photographer focused an 85 mm lens on the surface of the water to catch the shimmering details sharply.*

Everyday living

Some of the most fascinating contrasts between one place and another occur at the level of daily life. What is unremarkable to the local people – their work, domestic life and customs – provides a wealth of insights for the visitor, whether traveling in his own country or to more exotic places.

Photographs of people at work reveal much about their culture, as does the picture of Sri Lankan tea-pickers opposite. You must bear in mind that many communities begin the day very early, and you may have to rise at dawn to get the most lively pictures. Photographing the local form of transportation is another good way to convey the flavor of everyday life. Railways have a distinctive character in different countries, and you might frame a traveler in a car window, as in the picture below at left. Religion plays a major and visible role in many countries. The photographer of the Muslim at prayer, below, saw the opportunity for an unusual composition typifying the Islamic way of life.

You do not need any special techniques to obtain such intriguing vignettes: just an acute eye, a willingness to venture off the tourist track, and some discretion. For example, find out if photography is permitted before intruding into a place of prayer and always try to be unobtrusive.

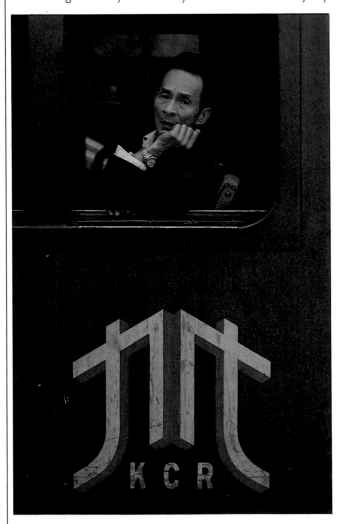

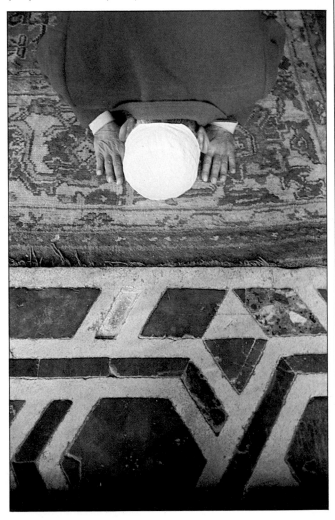

A railway passenger in *Kowloon, Hong Kong, gazes pensively from his window seat. The unusual framing produced an image combining the everyday and the exotic.*

A Muslim at the Blue *Mosque, Istanbul, prostrates himself in prayer. Standing on a step, the photographer pointed downward with a 35 mm lens at full aperture.*

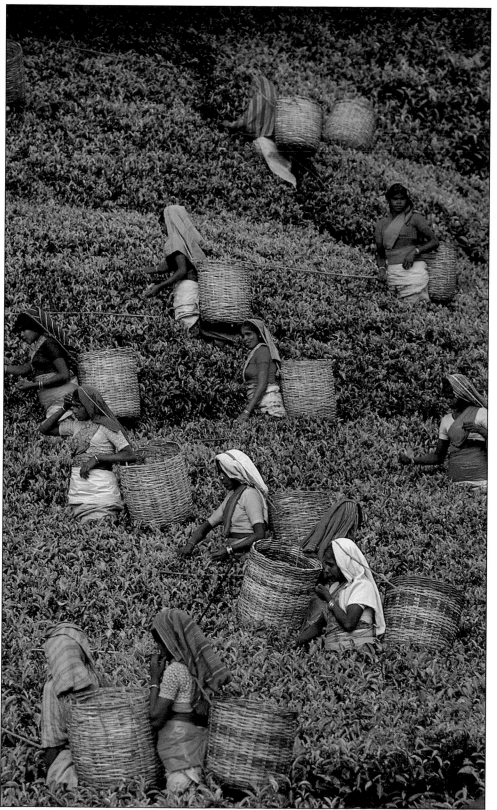

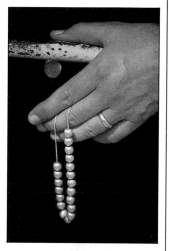

A string of worry beads
casually looped over a man's
sun-darkened fingers conveys
a ubiquitous facet of life in
Greece. The photographer
spotted the subject in a café
in Corfu and closed in with a
80-200mm zoom lens to frame
the hand and the silver beads
against the dark background.

Sri Lankan women pick
tea on a hill plantation.
To emphasize the patterns
made by the colorful figures
moving along the rows of tea
plants with their large back
baskets, the photographer
chose a vertical format and
used a 400mm telephoto lens
to compress the perspective.

Meeting places and markets

The central squares of many towns and villages allow unparalleled opportunities for candid, animated photographs of people absorbed in activity. Often such places provide a focus for regular social events, as with the gathering of old men playing bowls in the South of France below – an example of the kind of evening get-together to be found in many warm places. Most rural communities also hold regular markets which give a real insight into the local way of life and the people. Even the produce on sale is usually interesting, as in the picture at right below, in which the photographer has made an abstract pattern from a vendor's display of Mexican hats.

The bustle and energy of these places makes them exciting, but the constant movement of people can make photography difficult. One solution is to step in close with a 28mm or 35mm lens so that no one walks between you and your chosen subject. With a wide-angle lens of this kind you can also include the subject in the frame without needing to aim the camera so directly that the subject becomes tense. Alternatively, a medium telephoto (for example, a 135mm) allows you to stand back and still close in on individuals or details such as those in the picture at top right. A useful trick is to use the camera with both eyes open (not as difficult as it sounds) so you can see when unwanted figures are about to step into the frame. Have the camera controls set in advance, and use the smallest possible aperture so that critical focusing is unnecessary.

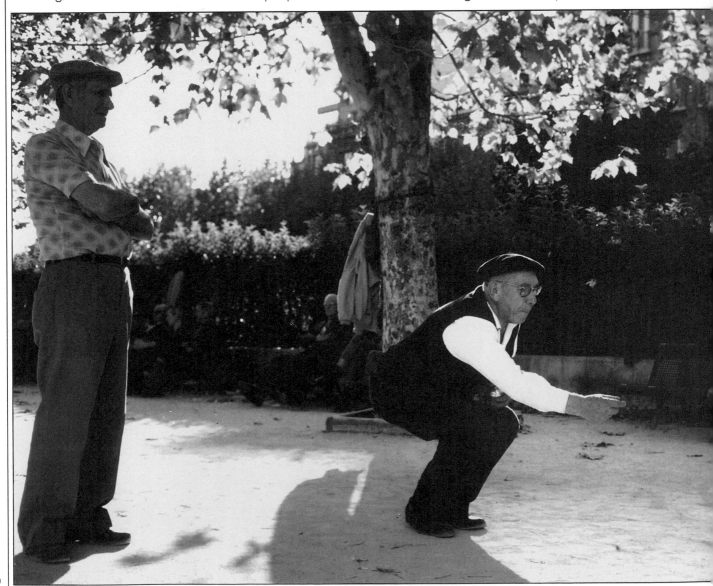

Money changes hands
(right) over a laden market
stall on the Caribbean
island of Curaçao. The
photographer closed in on
this detail from four feet
away with a 135mm lens, and
used a wide aperture of f/4
to blur the background.

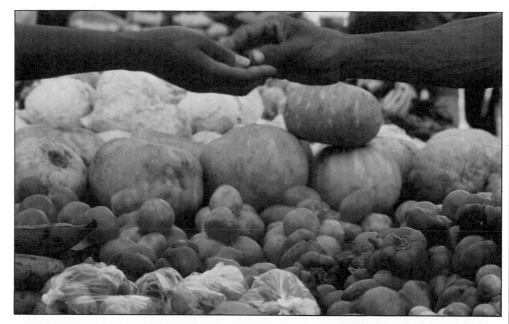

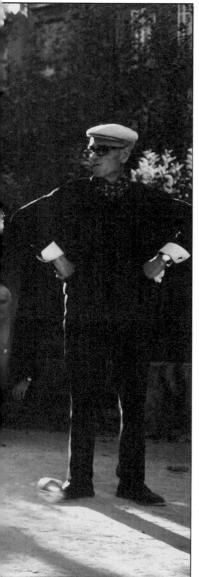

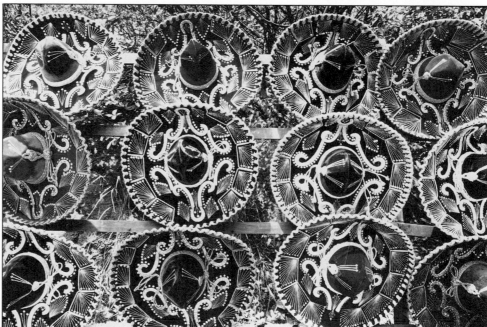

Souvenir sombreros (above)
hang in rows. A normal 50mm
lens filled the frame with
the hats from a distance of
about 10 feet. To emphasize
the symmetrical pattern, the
photographer stood directly
in front of the subject.

An old "boules" player
(left) takes his throw in a
square in Marseilles. The
photographer used a slightly
wide-angle 35mm lens to
include the other players.
Facing the sun, he gave one
stop more exposure than
the camera's meter indicated.

Images of the exotic

Strangeness and spectacle give pictures such as those on these two pages an immediate appeal. But none of these photographs was a lucky accident, a view that just happened on the way to somewhere else. In each case, the photographer learned in advance that a particular location would offer exciting possibilities and planned a visit accordingly.

The other common feature of these pictures – important if you are to make the most of exotic places – is the bold use of color. In the picture of the turban below and the dancer at top right, slight underexposure has ensured full saturation of the colors, even if detail has been lost in the shadow areas. For the temple view below at right, the photographer waited until nightfall and used daylight slide film to record the weird color effects of various types of artificial light.

Similarly, you should look for ways of transcending the obvious. A close-up detail, such as the red turban of a palace guard, may have more visual impact than a view of the whole edifice. A single dancer, circled by a flaming torch, can be more dramatic than a frame full of whirling figures. And a group of Buddhist shrines may need the soft glow of the temple lights at twilight to suggest their mystic enchantment.

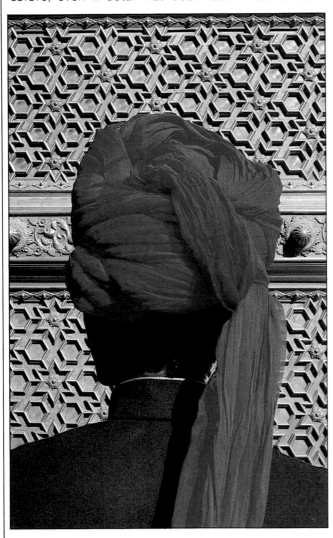

A turban glows against the backdrop of an elaborate bronze door at Jaipur, India. Close framing stressed the contrast between strong color and rich pattern.

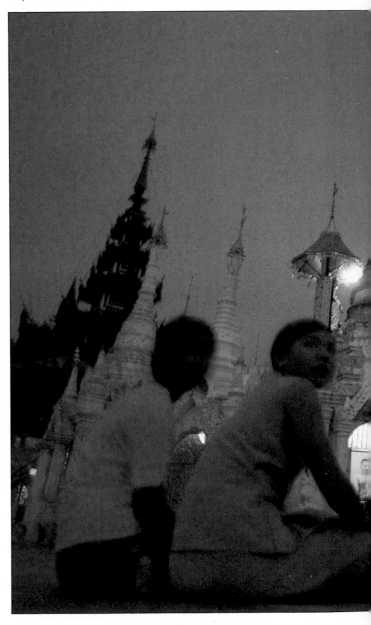

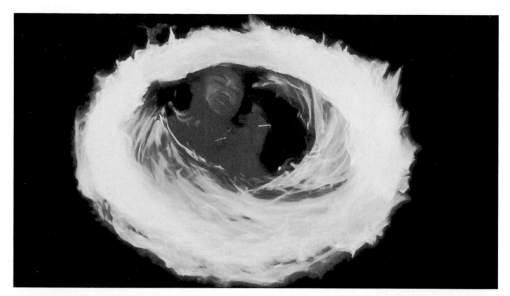

A circle of flames surrounds a Samoan fire dancer. The photographer crouched to line up the subject with an 85mm lens and set a slow shutter speed of 1/4 so the flaming torch would trace a blurred path around the dancer's face.

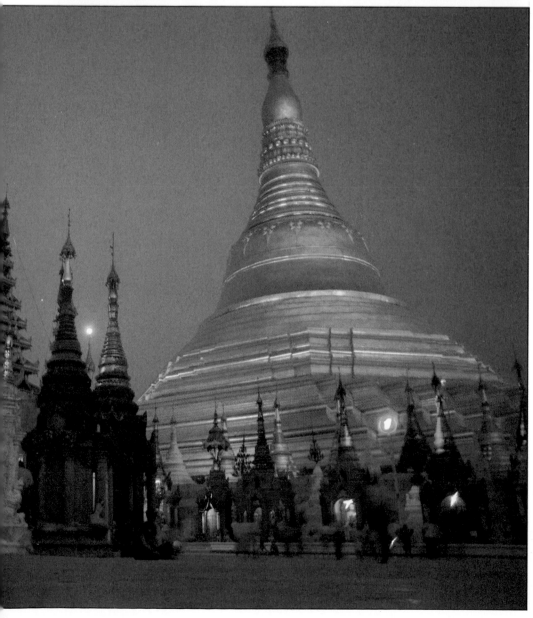

A mass of shrines surrounds a Burmese temple, photographed during a full-moon festival. Tungsten lights appear orange and vapor lights green on the daylight film. A 20mm wide-angle lens encompassed seated figures in the foreground and added distortion to the strangeness of the scene. Using ISO 64 film, the photographer bracketed the exposure, with 1/4 at f/4 giving optimum results.

73

Local characters

Photographs of people add interest and personality to your coverage of a location and sometimes are more expressive of the place than its landscapes or architecture. There are two approaches: the candid picture and the portrait. Circumstances usually dictate which is easier, although there is nothing to stop you from trying both. However, you must always respect an unwilling subject's privacy – a right that may be legally protected in some places.

For candid photography, in which people are unaware that you are taking their pictures, you need to be quick and decisive. A medium telephoto lens (105mm to 200mm) is most useful; you can frame a subject at full-length from between 25 and 50 feet. The pictures of the praying woman at top right and the traffic policeman at bottom left on the same page were taken in this way without attracting attention. Be unobtrusive yourself – for example, wear inconspicuous clothes and keep the camera out of sight. Have the exposure set before you raise the camera to your eye so you can take the picture swiftly. And if you are caught in the act, smile.

If your manner is pleasant, people will usually let you take a portrait. Simply ask politely if you may take a picture, and thank your subject afterward. In some exotic locations, people may be more reticent. One technique is to encourage curiosity, particularly among children. You can make a great show of photographing a view and then invite your potential subjects to look through the viewfinder – a simple ice-breaker that will soon have them eager to be in the picture.

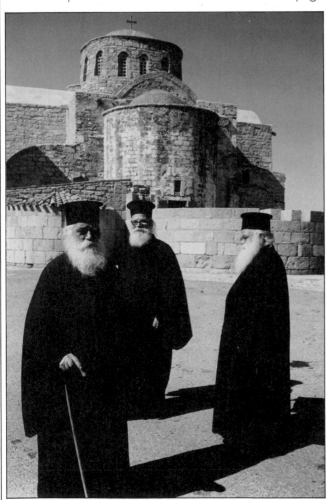

Three Greek priests *(above) stand in front of their church, carefully but informally posed. A 35 mm wide-angle lens set them in their context, the depth of field extending through the whole scene.*

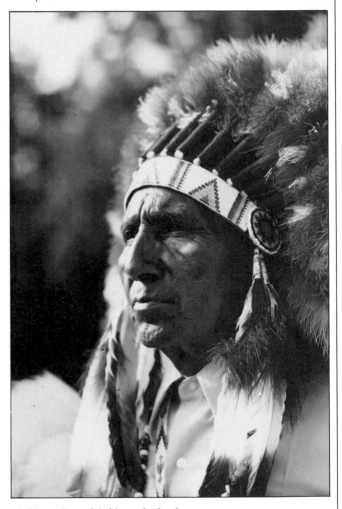

A Cherokee chief *in eagle-feather headdress posed for this picture (above). The photographer selected a viewpoint that included the distant trees as a simple, out-of-focus backdrop.*

An old Burmese woman (below) prays, kneeling on a pagoda floor in Mandalay. Discreetly using a 180mm lens from a doorway, the photographer set the exposure for the background so the woman appeared as a bold silhouette.

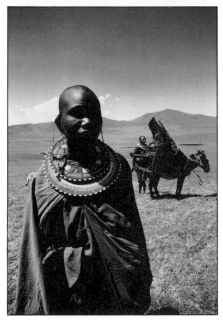

A Tokyo traffic cop (above) blows his whistle. The photographer used a 105mm lens to close in on the unaware subject, with a wide aperture of f/4 throwing the background out of focus.

A Taiwan actress (above) looks directly at the camera. Used to posing, she agreed to this close-up with a 50mm normal lens, its wide f/1.8 aperture helping in the low light indoors.

A Masai tribeswoman (above) fills the foreground of this picture taken in Kenya. The 35mm wide-angle lens made the distant hills look smaller and thus stressed the emptiness of the landscape.

Classic sites/1

To visit a world-famous site of great beauty and importance, and yet to be so familiar with pictures of it that it seems commonplace, is a frustrating experience. The Coliseum in Rome, the Parthenon in Athens, the Eiffel Tower in Paris – such sites are photographed by so many tourists that picturing them in a fresh way is a real challenge.

One point to remember is that these places have an equally stultifying effect on most photographers. Look at a dozen pictures of a famous landmark and you will see that the same viewpoint – often at the same time of day – has been used. So take the obvious pictures if you feel inclined, but then explore other possibilities.

A number of historical buildings are on such a grand scale that they dominate not only the immediate vicinity but a large surrounding area as well. The Eiffel Tower is a case in point: the familiar outline can be seen from many different parts of the city, and because the tower is instantly recognizable, you can afford to be adventurous in your approach to framing and viewpoint. The pictures on these pages show just a few of the possibilities. In the photograph below, the Eiffel Tower is a background element in a view across the city rooftops. On the opposite page, a wide-angle view from the base emphasizes the shape and structure of the tower. And in the picture at right, the tower itself provides an aerial view that includes its familiar shadow. By adopting similar approaches to other classic subjects, you can obtain images that convey all their imposing character – but in unexpected ways.

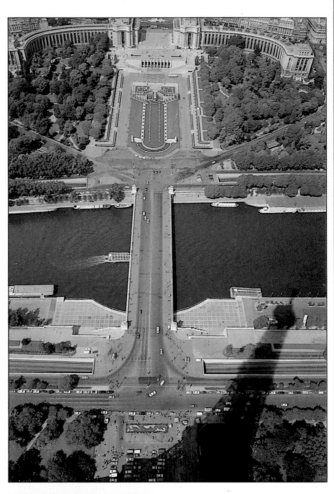

The shadow of the Eiffel Tower breaks up the symmetry of a bird's-eye view across the Seine to the Palais de Chaillot. The photographer took the picture from midway up the tower, choosing a time when the sun cast long shadows.

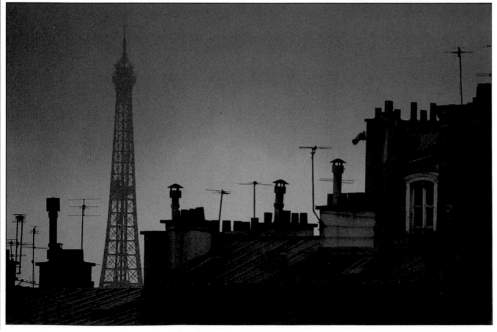

Montmartre rooftops make an unusual foreground frame for the tower, softly outlined against the dawn sky. The photographer used a 300 mm telephoto lens to compress the distance.

A floodlit view from the foot of the Eiffel Tower emphasizes the massive scale of the construction. A 16mm wide-angle lens exaggerated the span of the arches, and a starburst filter produced the radiating points of light at each of the corners.

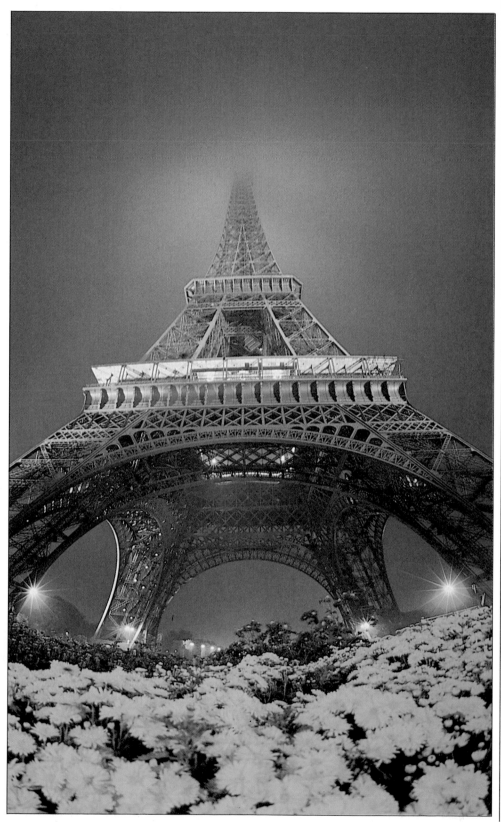

The looming shape of the tower dwarfs a church spire in the foreground. To stress the architectural contrasts, the photographer centered the subjects in the frame and used a 400mm lens.

Classic sites/2

Part of the challenge of photographing world-renowned places is knowing how to deal with the throng of visitors that ebbs and flows throughout the day, and with the clutter associated with tourism. Evidence of the modern age, such as roads, railings, street signs and souvenir sellers, intrudes even upon sites of great antiquity.

You can eliminate many of these distractions by a careful selection of viewpoint, camera angle and time of day. For example, to express the barrenness of Monument Valley in the picture below, the photographer left his car and climbed a small hillock at the roadside. From this vantage point, shadows hid the highway that crosses the landscape, and his picture shows this desolate place as it may have appeared before the coming of man.

When the scenery is on such a massive scale, individual figures become lost in the distance, but in a town or city they become more of a problem. Here, careful framing can help. In the pictures below and at right stone columns restrict the camera's view to sections of the scene that are uncluttered by people.

At night, floodlighting often makes beautiful or historic buildings stand out from their undistinguished neighbors, and gives a new look to much-photographed places. For example, in the picture at the bottom of the opposite page, the photographer exploited the drama of floodlighting and of a full moon to make a novel image from the familiar shape of London's Tower Bridge.

A stunted tree frames a desert buite in Arizona, drawing attention away from the road between the two. The photographer took the picture at dusk so that the low sun picked out the texture of the peeling bark and enhanced the impression of aridity and decay.

A row of pillars at St. Peter's, Rome, hides the crowds that fill the square outside and leads the eye to a pair of nuns. To make sure that the pillars appeared as true verticals, the photographer carefully leveled the camera before taking the picture.

Blocks and columns conceal the scattered ruins that ring the Parthenon, making a simple, graphic image. Bright sun made possible the use of a small aperture, so detail is retained in both near and distant parts of the scene.

Eliminating crowds
Just after sunrise, streets and tourist spots are usually free of crowds, as shown in the lower of the two pictures below. Expressive light and shade help too. If you have to photograph among crowds, use a small aperture and a 2.0 neutral (dark gray) filter. This should permit tripod exposures of several seconds, during which moving figures will form only an indistinct blur on film.

Ephesus, Turkey, at noon.

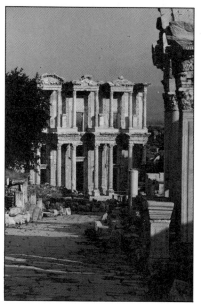

The same scene at 8 a.m.

A full moon, magnified by the photographer's 400mm lens, rises behind Tower Bridge. With the camera mounted on a tripod, the photographer gave a one second exposure at f/5.6 on ISO 64 film.

The original approach

The most fascinating images in a travel portfolio will reveal the photographer's individual interests. What attracts one person may go unnoticed by the next. Wherever you are, make a habit of carefully looking for the distinctive and original aspects of what you see around you.

A detailed approach, isolating just a small part of a scene, is the most effective means of putting your personal stamp on a picture. Frequently, you can frame and dramatize a detail more effectively by using a telephoto or zoom lens than by getting close with a normal lens. You might select a slightly incongruous element, such as the traditional-style clock in modern surroundings, below. Or you could frame a classic subject in a fresh way, as in the picture of the Statue of Liberty, opposite. Finally, remember that you can often make a more interesting picture by enlarging and cropping an image at the printing stage – as demonstrated by the photograph of the woman's capped head below at left.

An Amish woman (above) attends Sunday prayer in Lancaster, Pennsylvania. The photographer carefully cropped the detail from a larger image, taken on ISO 400 film – for a soft-toned grainy effect – with a 400 mm telephoto lens.

An ornate clock (right) hanging over an insurance building in the City of London bears the company's motto. The photographer used a 300 mm lens to throw the geometric lines of modern buildings behind out of focus, obtaining a contrast between old and new, but without clutter.

The head of the Statue of Liberty is tightly framed to make a semi-abstract image. Standing on Liberty Island, the photographer used a 500mm mirror lens to achieve this unusual view.

A cowboy's gun in its worn holster caught the photographer's eye in a reconstructed Wild West town in Tombstone, Arizona. A 105mm macro lens filled the frame with the detail.

Replicas on sale in a souvenir booth in Rome (left) invite comparison with their famous originals. The morning light behind the statuettes revealed their details through the transparent plastic.

The picture essay/1

One important aspect of travel photography is the way that different images work alongside one another. Trying to photograph picture essays is an excellent way to inject variety and a story telling element into a record of a trip.

There is no need to use many rolls of film to make an interesting and effective sequence. Thought and discrimination at the outset save a lot of editing later. A mini-essay such as the one shown here, comprising just a few well-chosen images, will form a self-contained feature in an album or, if you use transparency film, a special interlude in a slide show.

In a short sequence, aim for simplicity. Begin by selecting a clear, straightforward theme. Here, the photographer built the essay around beach life at a popular resort during the course of a day. Such open, natural locations are ideal settings for varied compositions with linked backgrounds. To make each picture count, you need dominant subjects without distracting elements in the surroundings, so that the viewer sees at once what you are trying to convey. Each image shown here makes a different point, but there is a clear continuity. An overall view of the crowded beach sets the scene. The photographer then closed in for two contrasting portraits of vacationers – one candid, one posed. The low-key mood and the time of day made the final image a natural choice to end the sequence.

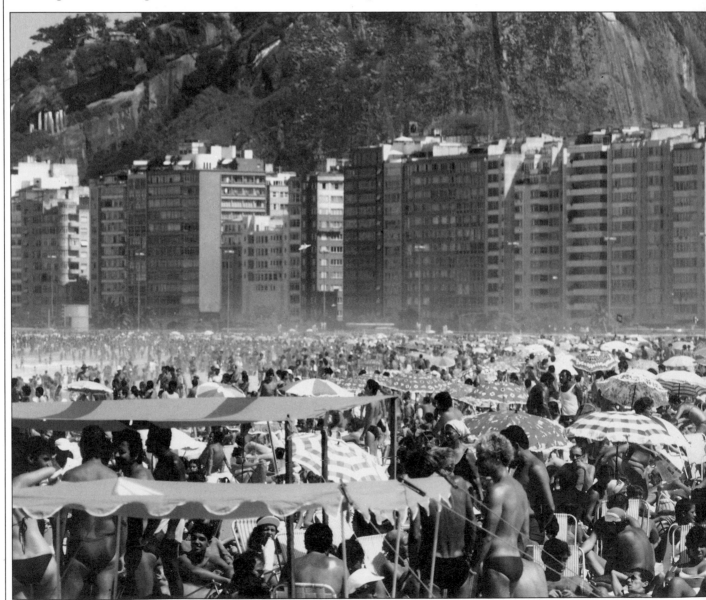

Relaxing in a deck chair, a man rests his fist on his bald head as if to shield it from the sun. Framing to emphasize the strong shapes adds to the image's humor.

In a bikini and baseball cap, a vacationer poses for the camera. The photographer closed in with a 100mm lens to focus on a smile that sums up the holiday spirit.

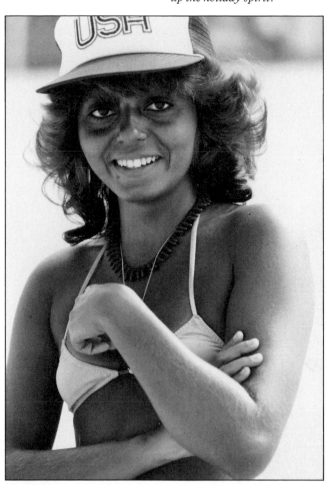

In the heat of the day, sun-seekers cover every inch of sand on Rio's Copacabana beach (left). A 300mm lens compressed the scene to give an even stronger impression of packed humanity.

Lost in a private world, lovers (below) stroll along the empty beach at sunset. The softly lit setting and the silhouetted figures made an atmospheric picture to bring the essay to a close.

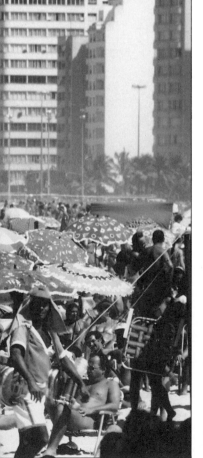

The picture essay/2

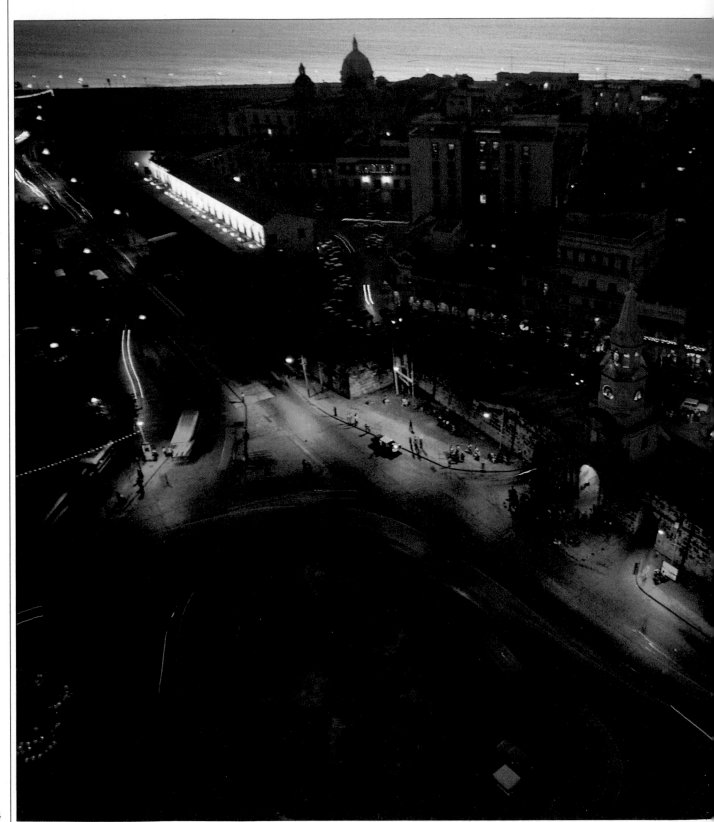

While single events or simple locations suit the mini-essay treatment, broader subjects – the life of a region you are exploring, or a city – merit a longer, in-depth approach. And to do justice to the wealth of subject material, you may need to spend several days working on a theme and finding the best images to express it.

The picture at left and those on the next two pages show how Michael Freeman, the consultant photographer for this book, approached a detailed photo-essay. His subject is the city of Cartagena, on Colombia's Caribbean seaboard. Freeman wanted to convey something of the city's fascinating history – it was one of the first colonial settlements of the Americas, and the capital of the Spanish Main – as well as its vibrant Latin culture and the tropical setting. Pulling these strands together required a clearly devised plan of action.

The first step was to make a list of topics: views of the setting; architecture old and new; portraits; street life; and activities and events unique to and typical of the place. From this list, Freeman chose subjects that most effectively conveyed the different aspects, taking viewpoints and time of day into account. Because Cartagena is built on several islands, surrounded by marshes and the sea, finding a good vantage point for a clear overview of the city was difficult. To take the scene-setting opener at left, Freeman went to the roof of a modern building in the early evening, used a wide-angle lens and waited until the streetlights came on. The next three pictures in the essay, on the following page, provide a contrast between old and new, with different lighting conditions emphasizing the shape or detail of the buildings. Next, two lively images of street life – a Cartagenero playing in a lunchtime band, and examples of local transport – present a more detailed approach. The essay ends with a very un-citylike picture. But in fact, the fishing scene is strongly typical of the place: such marshy waterways infiltrate Cartagena on all sides.

At twilight, Cartagena's city center twinkles with colored lights. Standing on a prominent rooftop, the photographer waited until just after sunset to get a mixture of natural and artificial light, and took the picture with a wide-angle 20mm lens for a broad panoramic view.

The picture essay/3

The late afternoon sun brings out the rich colors of the Spanish colonial-style cathedral (right). The photographer used ISO 64 film for good, strong detail, and closed in with a 400mm telephoto lens to bring the subject forward.

Modern high-rise buildings on one of Cartagena's islands (below) are softly outlined by the setting sun. From the vantage point of a hill overlooking the island and the bay, the photographer was able to include the shimmering wash of gold on the water and the fringed shapes of palms suggesting a tropical setting.

Tiled roofs and jutting balconies (above) overhang a narrow street in an old quarter of the city. The crosslight from a low sun revealed the textures of the bleached stone walls and rough tiles.

A band musician plays his saxhorn during a lunchtime performance. Using a 180mm lens, the photographer closed in for a head-and-shoulders portrait of the player, centering the subject in the frame and throwing the surroundings out of focus.

Gaily decorated local buses crowd a main street. The photographer chose a high camera position and a diagonal view to convey lively movement in this typical scene, and used a medium telephoto lens to fill the frame with the subjects.

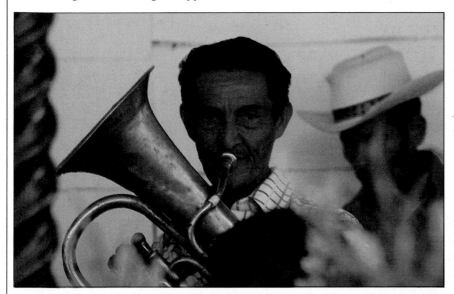

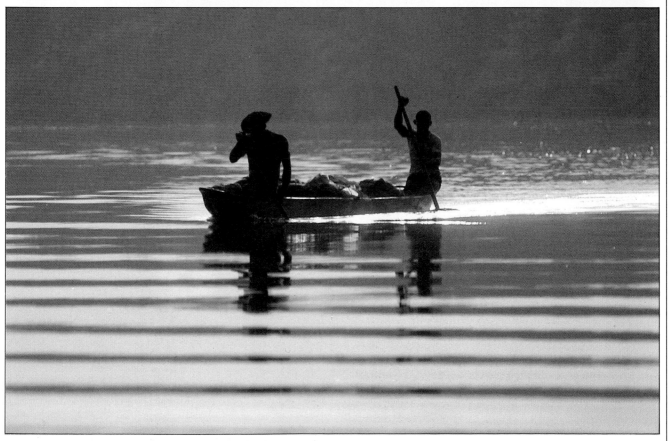

Fishermen paddle their boat on a still lagoon at sunrise. Both the subject and time of day form an effective contrast, in mood and color, with preceding images. The photographer used a 400mm telephoto lens at an exposure of 1/125 at f/5.6.

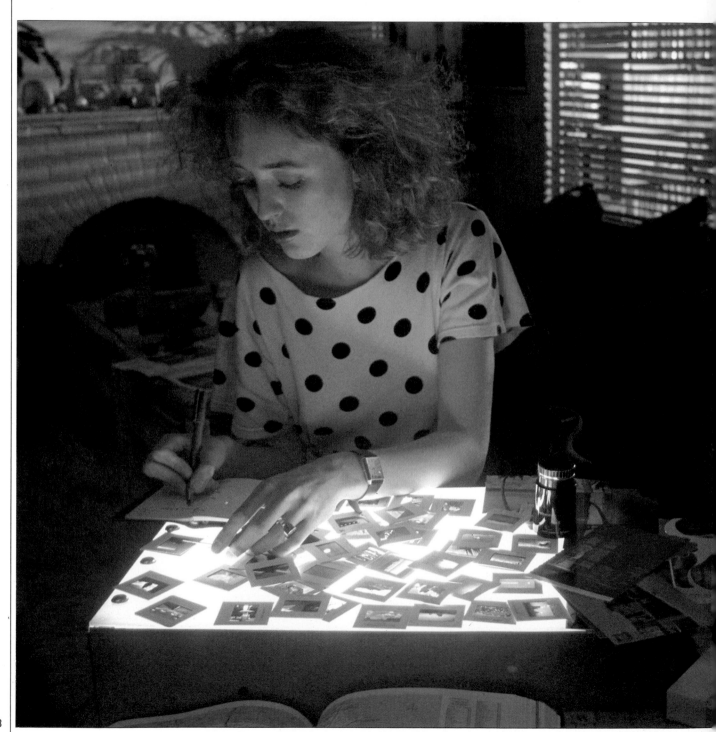

PUTTING IT
ALL TOGETHER

Photographs are meant to be seen, and the lasting pleasure of travel photography comes when the trip is over and you can browse through your prints and slides. Selecting, arranging and presenting your pictures are as much parts of the creative process as taking photographs, and deserve as much care.

The advance planning, the local research and the notes you made on pictures along the way will now pay off. Instead of a random heap of images, including some you cannot identify, you will have a unique and vivid record of your whole trip. The following pages explain how to put your pictures in order, and then how to show them to the best effect – either in the form of an album or as a slide show, perhaps using a soundtrack with commentary. You might choose to arrange pictures consecutively, in order of the places visited; or according to one or more themes planned at the time. At the sorting stages, make sure you have plenty of space to spread out prints, or, as shown here, a light box for viewing slides, so you can study the images together. And keep an open mind – you may find that an unexpected theme suddenly occurs to you.

A photographer examines her travel slides on a light box and lists their details in a notebook. Postcards and maps help her to identify the subjects and locations, and boxes of slides are labeled for easy reference.

Processing and editing/1

After your trip, the first task is to process the film. Whether you have taken a lot of pictures or just a few, you will want to ensure that this irreplaceable record of your vacation is reliably developed.

Whereas color print or black-and-white film can be controlled at the printing stage, for color slides processing provides the last real opportunity for controlling the images. Some laboratories can adjust the development cycle of slide film to compensate for slight exposure errors or for the underexposure of film that you may have deliberately pushed when taking pictures in dim light – as explained below.

If possible, use a lab that has successfully processed your slides before, and do not send in all the rolls of film in one batch. Try just one roll in advance of the rest. By looking at these test pictures, you will be able to judge whether your camera was consistently exposing the film correctly. And if not, you can ask the lab to rectify the error by altering the development time.

Labs that process color prints usually work on a production-line basis and cannot make the adjustments to the processing cycle that are possible with slide film. Because your film may be processed along with thousands of others, a wise precaution is to label each roll with your name and address. Make a separate note of the subject matter of the pictures, too, as this will help the lab to locate your film if it is ever mislaid.

After processing, sort out prints for enlargement or slides for projection. Throw away those that are spoiled by camera shake, inaccurate focus or exposure errors, and carefully examine the others to pick out the best. Images that look good at a superficial glance may fail to live up to your expectations when you examine them with a magnifier. The pictures on the opposite page show how one photographer selected his best pictures from a developed roll. However, keep any second-choice pictures; later they may fill a small gap in a slide show or album.

Fine-tuning slides

All slide film except Kodachrome film can be made darker or lighter at the time of processing. Extending the development time makes the picture lighter – a method known as push-processing. Reducing the time darkens the picture, and this is called pulling the film. You can request such a change in development to compensate for over- or underexposure, perhaps if setting the camera's ISO dial to the wrong speed. If you are not sure how much change is needed, ask for a "clip test." The lab staff will snip off the first three or four frames of your film and process them in advance of the rest. By examining the clip, you or a technician from the lab can decide how much darker or lighter the pictures ought to be. Then adjustments to the processing may produce the necessary improvements.

A clip test indicates one stop underexposure on the two frames shown.

The correct density is achieved in a slide from the same film by pushing the film one stop to compensate and brings out the sky's rich colors.

A walk in London
From a roll of film, the photographer was happy with only about half the pictures, as explained here.

A passing car spoiled this picture of a policeman giving directions.

These three views of a street market show how three approaches – a horizontal and vertical framing, and the inclusion of a figure – produce equally acceptable images of the same subject matter.

Out of four pictures of a marching band, only the first two are satisfactory. In the third picture, half the soldiers are out of focus, and in the fourth, the top of the guardsman's head is cut off.

To cope with the high lighting contrast in this view of a sunlit building, the photographer took three bracketed pictures. The middle picture was best.

By changing viewpoint and lens, the photographer was able to include a sunbather, and thus greatly improve on his first three pictures of a city fountain.

Processing and editing/2

To make sense of your travel pictures, sort them into categories, grouping pictures together either chronologically in the order of the places you visited or by subject matter. Unless you have taken just one or two rolls of film, it is essential to be systematic in this period of sorting and reviewing or you may become hopelessly confused.

If you used slide film, a light box, shown in the picture below, makes editing easier. You can improvise one of these by using a backlit sheet of opal glass or plastic. Mounted slides form precarious piles when stacked up so use vinyl sheets with pockets to help to keep them in order. Alternatively, if you develop your slides in a home darkroom, you can defer mounting and keep the film in several strips until you have chosen the images you want to keep.

Sorting slides (below)
With the aid of a light box, you can see immediately which slides are usable and which to discard. A 4x or 8x magnifier is an essential aid in making a selection. Copy the caption details onto the back of the slide mounts and put the slides in vinyl sheets. Many laboratories will, at your request, return slides unmounted, in clear plastic sheets such as the example at left below. You can mark these sleeves with a wax pencil to indicate your chosen pictures.

Mounting slides (right)
If you develop your own color slide film or order it from a lab unmounted, you can use simple and cheap cardboard mounts (1). These hold the slide in place with adhesive. Optional plastic sleeves (2) protect the film from scratches. Processors mount slides in cardboard or simple plastic mounts (3). For maximum protection against marks and fingerprints, use mounts with glass covers (4).

Plastic slide boxes (below)
These are fine for storing rarely needed slides, but finding a particular image means emptying the whole box – and this takes time.

Processing labs will also leave off the mounts if you want to supply your own.

You can have both color negative and color slide film printed either as individual postcard-sized images or as a contact sheet. Advantages of a contact sheet are that you can file the sheet alongside the originals and that pictures are often easier to compare with one another. However, you do need a magnifier to see the images clearly.

Postcard-sized prints are simpler to look at, but to keep them in order you should write on the back of each the roll and frame number of the negative to which the picture corresponds. This saves confusion when ordering reprints. The easiest way to store large numbers of small prints is to file them in a card index as shown below.

Card index (left)
This will effectively store large numbers of postcard-sized prints. Roll and frame numbers on the back of each picture enable each one to be quickly matched to its own original. Store the negatives separately.

Cardboard L-frame (below)
This is a useful aid to visualize how a small print will look if you want to have it cropped and enlarged.

Postcard-sized prints
These are what customers ordinarily receive from lab-processed negatives and are good for looking at with friends. But stored in the processer's envelopes, specific pictures are hard to find. Instead, you can order a contact sheet (right) that shows every frame on a single sheet and thus makes it easier to locate those images that you want to have enlarged. Here the photographer has examined the contact sheet with a magnifier, crossing through faulty images.

A travelogue in slides/1

The most impressive way to display travel pictures is in a slide show. Even at the simplest level, using only a manual projector (below, top) and an accompanying script, images enlarged on a screen come to life and take on a narrative flow.

The essentials for a slide presentation are a projector, a screen and a viewing area that can be thoroughly darkened. In a fully darkened room, a white wall will serve as a screen, but a wall-hung or tripod-mounted screen, as at right, will normally work better. The conditions you create for viewing are just as important as the show itself. Any light spilling onto the screen will weaken the images, so if you cannot successfully black out a room, present the slides at night. Check that the projector and screen are at the correct heights and distance apart

— see the diagram on the opposite page. Make sure, too, that your viewers will be comfortable and have a clear view of the screen.

For a more ambitious show, you might use one of the semi- or fully automatic projectors shown below at right and at bottom. Automatic focusing is a useful feature — in some cases you adjust focus by remote control; in others the projector focuses entirely automatically. A rotary slide tray helps to ensure a smooth sequence of images; and for a truly sophisticated show, you might link two projectors to a dissolve unit. With this unit you can fade out one projector lamp as the other brightens so that one image dissolves into the next and the screen is never blank. Most dissolve units can also be programmed to synchronize the slide show with a tape recorder.

Slide projectors

The illustrations below show the three main types of slide projectors that are available, which range from completely manual machines to those that are fully automatic. Some models have timers to change slides automatically.

A simple manual projector (right) has a push-and-pull slide carrier. The fixed lens offers only limited focusing control.

The automatic projector below takes a tray of 30 to 40 slides, and has an interchangeable lens. Autofocusing corrects the image if slides vary in thickness.

A Carousel projector (right) holds a rotary tray of 80 slides. It has remote control and focusing, and a timer for projecting slides automatically at preset intervals. Gravity feed lessens the risk of slides getting jammed.

150mm lens
12ft 6ins distance

100mm lens
8ft 4ins distance

60mm lens
5ft distance

Projection distances
The size of the screen image depends on the focal length of the projecting lens and the distance from the projector to the screen. The diagram above suggests the lenses and corresponding distances to project a good-sized image onto an average 3 × 3ft screen, as at left.

Compact projection
The illustrations at right show two projectors suitable for small slide presentations. A daylight projector, near right, has a built-in screen to view and show slides without the need for a darkened room. A back-projection console, far right, incorporates a tray for 80 slides, a display screen and an audio input unit, so that a soundtrack can be synchronized with the slides.

A travelogue in slides/2

There are two basic rules for organizing a slide show: first, prepare everything in advance, and second, keep your presentation short. Try to work out a logical order, one that tells the story in a straightforward way. Some techniques are shown in the panel below. You should also look for visual continuity; several ways of linking sequences of pictures are shown at right.

Above all, avoid straining your audience's span of attention. If in doubt, err on the side of brevity. Your subject will have to be extremely interesting to warrant a showing time longer than 20 minutes, and 15 minutes is a sensible maximum. Plan to have the majority of your slides on the screen for less than 10 seconds, and never leave them up for more than 30 seconds unless you are answering questions. Try to vary the pace of the show: several views of the same scene should be given a few seconds each; one overall view with lots of detail, a longer time. As a starting point, you should aim to select about 80 slides for a typical show — the capacity of an average slide tray.

Creating a script
To see how your planned order will work out, sketch the slides in numbered sequence on large sheets of paper. Use these storyboards for final adjustments and to decide how long to hold each picture. Then write your commentary in a notebook and use a watch to keep on schedule during the show itself.

Tell a story
The simplest way to link a series of slides within an overall presentation is to follow the time sequence in which the pictures were taken. This is very effective with action events such as the Colombian bullfight shown here, where we see the matadors waiting and then move on to the actual playing of the bull. Sports events, processions and ceremonies all work well in this way.

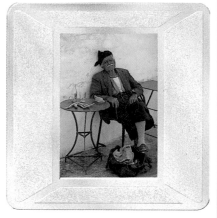

Repeat a motif
You may find that several of your pictures include similar subjects such as the hand-shaped door knockers from Athens above. These can be effectively run together as a sequence within your show, but be careful not to hold them on the screen for too long.

Make transitions gradual
This sequence illustrates how to move smoothly from one place to another by including a linking slide. The top picture is from a sequence showing a Greek island's fishing port. To link this with inland pictures, the photographer included a slide of a fisherman mending his nets. The following slide picks up the theme of local characters, with an old man sitting outside a bar.

Repeat shapes or colors
You can use the abstract qualities of certain pictures to connect seemingly random groups. The sequence above, in London's commercial center, repeats the use of a distinctive oval shape – in a brass bell push for bank messengers; the center of a famous gold plate; and an oval window framing one of the Bank of England's towers. You can also repeat areas of color for a similar effect.

A travelogue in slides/3

You will almost certainly encounter gaps in your pictorial record when editing a slide show. There will be subjects you wish you had photographed for continuity or others that would have given valuable information about the location or layout of the place you photographed. Perhaps a particularly good picture will be difficult to include because you took no others that would put it in context.

Among the most useful gap fillers are pictures that help to provide transitions between different locations. Here, travel pictures taken from trains, cars or planes can help. If you hunt through your discarded pictures you may find one that was not good enough to survive your first edit but that works well as a simple linking device. You can also

provide a link by photographing a map of your route as shown below. Use one of the copying techniques explained at the bottom of this page.

Another idea is to fill gaps with pictures of the souvenirs you brought back – craft objects, local currency (as below, left), tickets, visa stamps in your passport or stickers on your baggage.

For a final flourish, you may like to prepare attractive, professional-looking titles to appear at the beginning of the show and to separate various sections. Simply photograph the lettering for these titles onto slide film. As shown on the opposite page, you can also sandwich a title slide with a picture slide so that the two appear together to create an even more polished effect.

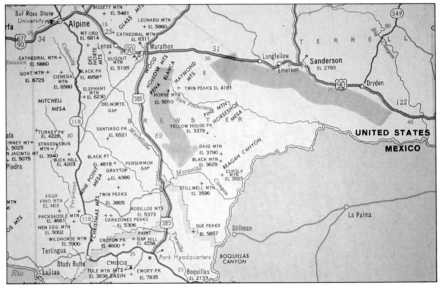

Copying to fill the gaps
The view of the Thai temple above comes from currency, copied in close-up as an interesting link in a slide show. For the map (right) used in another show, the photographer marked his route in green ink before making a copy on slide film. To do this kind of close-in copying you will need a macro lens, a supplementary close-up lens or extension tubes.

Light from a window – not direct sun – is adequate for basic copying. Pin the subject on a board near the window and line up the camera on a tripod. Hold a white cardboard reflector on the side away from the window for even lighting.

You can also use a small flash unit or a photolamp for copying. Place the light to one side of the subject, pointing obliquely across, with a reflector on the far side. A light placed too near the camera may reflect back as flare.

The best arrangement is two balanced flash units or photolamps, one on each side of the subject. If you possess a tripod with a reversing center column, you will get good results by aiming downward, with the subject on the floor.

Adding titles

The picture at right of St. Peter's Square in Rome, titled to appear at the start of a sequence, actually consists of two transparencies sandwiched together. First select a picture that seems to be suitable as an introductory image for the pictures that follow. Make sure it has a large, plain, light area into which you can insert the title. Keep the planned design simple for maximum clarity.

1 – Sketch the design of the chosen slide with the lettering in position and then buy some transfer lettering of a size appropriate for the white cardboard you will photograph. You can letter by hand, but the effect will be less neat.

2 – Make sure the white cardboard is big enough for you to position the letters according to your design. Use the edge of a piece of paper to keep the letters straight, and transfer them with the rounded end of a small paintbrush.

3 – Make a drawing on tracing paper of the final image you want, and check the positioning to photograph the lettering on slide film. Give $2\frac{1}{2}$ stops more exposure than indicated by the camera's meter so the white will be quite clear.

4 – Remove the original slide from its mount and stick a small piece of adhesive tape along one edge, taking care not to cover any of the image area. You must also be careful not to touch the image or scratch the surface of the emulsion.

5 – Attach the processed slide containing the lettering to the picture slide with the adhesive tape. Be careful to line up the frame edges perfectly and make sure there is no dust caught between the two slides to spoil the effect.

6 – You then mount the combined slides in the normal way. If your projector accepts the thicker type of mount, protective glass-covered mounts will work best, as they will squeeze the two slides together more tightly.

Presenting the prints

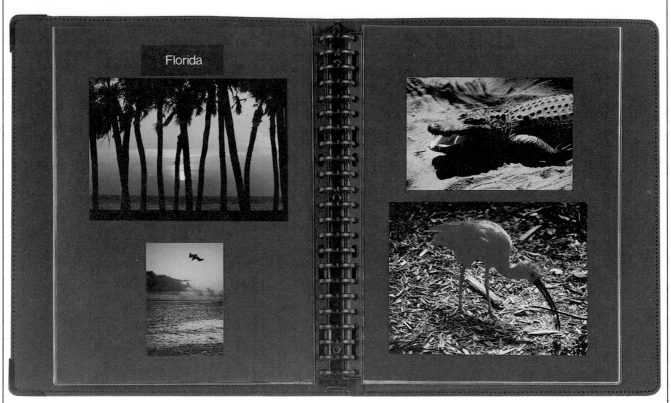

Photo albums

Probably the best photo album is one you make yourself after buying the raw materials from an art supplier. The example above, showing a selection of pictures taken in Florida, uses a ring binder with clear plastic sleeves. The photographer first designed the layout of each page, then had the prints made to a suitable size and mounted them on stiff black paper. For captions, you can use transfer lettering, here in white, or ink. If you want to caption every picture, a designer's stencil is a good tool. For a less ambitious approach, use a ready-made album such as the two shown at right. One has a clear-plastic film that you peel back and then place over the picture, and the other has plastic sleeves into which you can neatly slide postcard-size prints.

Prints can form the basis of a coherent travel story just as effectively as slides can. With a little flair and imagination, you can preserve and present them as a kind of personal publishing venture in the form of a photographic album specially devoted to your trip.

Decide first on the planning of the album: perhaps a time sequence following your itinerary, or maybe a series of "chapters," each based around a specific subject. For example, you could begin with scene-setting landscapes, then move on to people, then interesting buildings and so on. If you have an isolated sequence, a story within a story, you could devote two to four pages to that alone, and feature it by mounting the pictures on stiff paper backing of a different color or by drawing box rules around these particular prints.

Some alternative ideas are shown below. These examples take advantage of the relative low cost at which you can have black-and-white prints made to size, but you can do the same thing with color. Again, remember that often you can improve your composition when printing by cropping out unwanted parts of the image. You might like to group together pictures that are special favorites and frame them to decorate your home. Alternatively, you can frame travel prints on black or coloured mats and store them in a box as a unified sequence for personal study and reference.

Other display systems
The standing folder (above at left) displays several pictures on the same theme – California's Death Valley. Mount prints on paper or cardboard and then glue a framing mat to the front. Use heavy adhesive tape at the back to secure the accordion joints. For a boxed set (above), find a suitably sized box or make one out of cardboard. Have the prints made to a regular size and mount and frame them with cardboard. For a wall display, frame pictures individually in the normal way or mount them up together, as with the studies of the Greek island of Corfu at left. This ready-made frame consists of a simple clear-plastic box which is so easy to fill with pictures that you can change the display periodically.

Glossary

Aperture
The opening in a lens diaphragm that admits light. Except in very simple cameras, the aperture can be varied in size to regulate the amount of light passing through the lens to the film.

Automatic exposure
A system that automatically sets correct exposure by linking a camera's exposure meter with the shutter or aperture or both. There are three main types: aperture priority (the most popular), when the photographer sets the aperture and the camera selects the appropriate speed; shutter priority, when the photographer chooses the speed and the camera sets the correct aperture; and programmed, when the camera sets both the aperture and the shutter speed.

Backlighting
A form of lighting in which the principal light source shines toward the camera and lights the subject from behind.

Bracketing
A way to ensure accurate exposure by taking several pictures of the same subject at slightly different exposure settings above and below (that is, bracketing) the presumed correct setting.

Cassette
A metal or plastic container for 35mm film with a tongue to be threaded to a rotating spool within the camera. After exposure the film is wound back into the cassette before being unloaded.

Close-up lens
A simple one-element lens, placed over a normal lens in the same way as a screw-on filter, allowing the camera to be focused closer to a subject.

Contact print
A negative-size print made by exposing light-sensitive paper in direct contact with a negative.

Depth of field
The zone of acceptable sharp focus in a picture, extending in front of and behind the plane of the subject that is most precisely focused by the lens.

Exposure
The total amount of light allowed to pass through a lens to the film, as controlled by both aperture size and shutter speed. The exposure selected must be tailored to the film's sensitivity to light, indicated by the film speed rating. Hence overexposure means that too much light has created a slide or print that is too pale. Underexposure means that too little light has resulted in a dark image.

Extension tubes
Metal tubes that can be fitted between the lens and the camera body to increase the distance between the lens and the film and so make focusing on very near objects possible.

Film speed
A film's sensitivity to light, rated numerically so that it can be matched to the camera's exposure controls. The two most commonly used scales, ASA (American Standards Association) and DIN (Deutsche Industrie Norm), are now superseded by a new system known as ISO (International Standards Organization). A high rating denotes a fast film, one that is highly sensitive to light.

Filter
A thin sheet of glass, plastic or gelatin placed in front of the camera's lens to control or change the final picture.

Flash
A very brief but intense burst of artificial light, used in photography as a supplement or alternative to any existing light in a scene. Batteries supply the power to most flash units. Some small cameras have built-in flash, but for most handheld cameras, independent flash units fit into a slot on top of the camera.

Focusing
Adjusting the distance between the lens and the film to form a sharp image of the subject on the film. The nearer the object you wish to focus on, the farther you have to move the lens from the film. On most cameras you focus by moving the lens forward or backward by rotating a focusing control ring.

Format
The size or shape of a negative or print. The term usually refers to a particular film size, for example 35mm format, but can be used to distinguish between pictures that are upright (vertical or "portrait" format) or longitudinal (horizontal or "landscape" format).

Macro lens
A lens specifically designed to focus on subjects very near to the camera.

Mount
A cardboard or plastic mat used to support and protect transparencies.

Neutral density filter
A gray filter used to cut the amount of light entering the lens without affecting color balance.

Normal lens (standard lens)
A lens producing an image that is close to the way the eye sees the world in terms of scale, angle of view and perspective. For most SLRs the normal lens has a focal length of about 50mm.

Polarizing filter
A filter that changes the vibration pattern of the light passing through it, used chiefly to remove unwanted reflections in an image or to darken the sky.

Projector
A machine incorporating a light source and a lens, used to throw enlarged images of slides onto a screen.

Pushing the film see UPRATING

Push-processing
Extending development time, usually to compensate for underexposure caused by a film being uprated to permit a faster shutter speed than the light allows.

Sandwiching
The projection or printing of two or more negatives or slides together to form one composite image.

Standard lens see NORMAL LENS

Stop
A comparative measure of exposure. Each standard change of the shutter speed or aperture (for example, from 1/60 to 1/125 or from f/2.8 to f/4) represents a stop and doubles or halves the light reaching the film.

Telephoto lens
A lens that includes a narrow view of the subject in the picture frame, thus making distant objects appear closer.

Tripod
A three-legged camera support. The legs (usually collapsible) are hinged together to a head to which the camera is attached.

Ultraviolet
A form of electromagnetic radiation close in wavelength to light. UV radiation is invisible to the human eye but can affect film, sometimes causing a blue cast unless removed by a filter.

Uprating (pushing the Film)
Setting the camera's ISO dial to a number higher than the nominal speed of the film, so that the photographer can use a faster shutter speed or smaller aperture. To compensate for the deliberate underexposure that pushing produces, the film must be push-processed.

Wide-angle lens
A lens with a short focal length, thus including a wide view of the subject.

Zoom lens
A lens of variable focal length. For example, in an 80–200mm zoom lens, the focal length can be changed anywhere between 80mm and 200mm.

Index

Acknowledgments

Picture Credits
Abbreviations used are: t top; c center; b bottom; l left; r right.
Other abbreviations: MF for Michael Freeman, JG for John Garrett, Magnum for The John Hillelson Agency, IB for Image Bank, RL for Robin Laurance and SGA for Susan Griggs Agency.

Cover Andy Jillings

Title Jeff Hunter/IB. **7** Joseph F. Viesti/SGA. **8-9** JG. **9** Ted Spiegel/SGA. **10** Andrew De Lory. **11** Andrew De Lory. **12** RL. **13** John Sims. **14** Peter Keen/SGA. **15** Bruno Barbey/Magnum. **16-17** Victor Watts. **18-19** RL. **19** t, b Mireille Vautier/de Nanxe. **24** MF. **25** t John Starr. **26** b Peter Gittoes. **27** l JG, r Tim Ashley. **28** John Heseltine. **28-29** Graeme Harris. **30-31** George Hall/SGA. **31** tl Peter Gittoes, tr MF, bl Harold Sund/IB, bl Angela Murphy. **33** tl JG, tr Nathan Benn/SGA. **34-35** Jason Shenai/SGA. **35** t Tessa Traeger, b RL. **36** l Dr A. Berger/Daily Telegraph Colour Library, r Pat Morris/Daily Telegraph Colour Library. **37** l D. Williams/Daily Telegraph Colour Library, r R.G. Williamson/Daily Telegraph Color Library. **38** MF. **39** ml, mr, bl, br S & O Mathews. **40-41** Burg Glinn/Magnum. **42** t Amedeo Vergani/IB, b Michelle Garrett. **43** JG. **44** R. Mitchell. **44-45** MF. **46** l Alastair Black, r Paulo Curto/IB. **47** H.W. Hesselmann/IB. **48** Alastair Black. **48-49** Alastair Black. **49** Angela Murphy. **50** t Peter Runyon/IB, b Farrell Grehan/SGA. **50-51** Bill Brooks/Daily Telegraph Colour Library. **52** Gilles Peress/Magnum. **53** David Hiser/IB. **54** H.R. Uthoff/IB. **54-55** Bill Brooks/Daily Telegraph Colour Library. **55** Naresh Singh. **56-57** Michael Salas/IB. **57** t John Cleare, bl Dennis Stock/Magnum, br John Sims. **58-59** Adam Woolfitt/SGA. **59** Mireille Vautier/de Nanxe. **60** l Adam Woolfitt/SGA, r MF. **61** Burt Glinn/Magnum. **62** Ian Berry/Magnum. **62-63** Francois Dardelet/IB. **63** t, b MF. **64-65** H. Veiller/Explorer. **66** l Bullarty/Lomeo/IB, r Anne Conway. **67** t, b Michelle Garrett. **68** l, r RL. **69** l MF, r JG. **70-71** Richard Kalvar/IB. **71** t Lisl Dennis/IB, b Barry Lewis/Network. **72** Lisl Dennis/IB. **72-73** MF. **73** Pete Turner/IB. **74** l Brian Seed/Click/Chicago, r Mireille Vautier/de Nanxe. **75** t MF, bl RL, bc Bob Croxford, br JG. **76** t Anne Conway, b MF. **77** l, r Alain Choisnet/IB. **78** l Erwin Stegmann, r Bullarty/Lomeo/IB. **79** tl Pete Turner/IB, tr RL, bl MF, br Neill Meneer. **80** l Jake Rajs/IB, r Mireille Vautier/de Nanxe. **81** t Ian Murphy, bl Richard Haughton, br Andrew De Lory. **82-83** All RL. **84-85** MF. **86-87** All MF. **88-89** JG. **90-91** All MF. **92-93** All JG. **96** All MF. **97** tl, cl, bl, tr, cr, br MF, tc, cc, bc JG. **98** l, r MF. **99** John Sims. **100-101** JG.

Additional commissioned photography by Michael Freeman, John Garrett, John Miller, Victor Watts

Acknowledgments AICO (UK) Ltd., Cowling & Wilcox, Gnome Photographic Products plc, Keith Johnson Photographic, Nikon UK, Olympus Cameras, Wallace Heaton

Artist David Ashby

Retouching Roy Flooks

Kodak, Ektachrome, Kodachrome and Kodacolor are trademarks

Time-Life Books Inc. offers a wide range of fine recordings, including a *Big Bands* series. For subscription information, call 1-800-621-7026, or write TIME-LIFE MUSIC, Time & Life Building, Chicago, Illinois 60611.

Notice: all readers should note that any production process mentioned in this publication, particularly involving chemicals and chemical processes, should be carried out strictly in accordance to the manufacturer's instructions.